ANNETTE MESSAGER

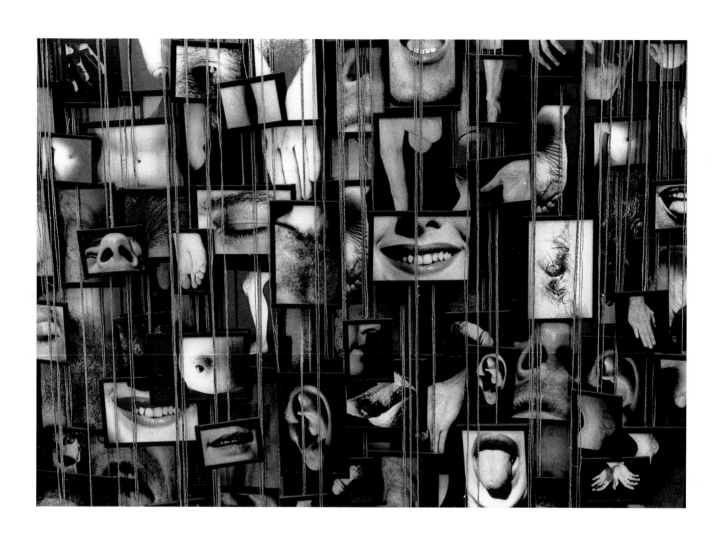

ANNETTE MESSAGER

Sheryl Conkelton and Carol S. Eliel

Los Angeles County Museum of Art

The Museum of Modern Art, New York

Distributed by Harry N. Abrams, Inc., New York

Published in conjunction with the exhibition *Annette Messager* at the Los Angeles County Museum of Art, June 15 to September 3, 1995; The Museum of Modern Art, New York, October 12, 1995, to January 16, 1996; and The Art Institute of Chicago, February 17 to May 5, 1996. The exhibition was organized by Sheryl Conkelton, Associate Curator, Photography, The Museum of Modern Art, New York, and Carol S. Eliel, Associate Curator, Twentieth-Century Art, Los Angeles County Museum of Art. The exhibition and its accompanying publication are supported in part by generous grants from the AFAA (Association Française d'Action Artistique–Ministère des Affaires Etrangères) and the National Endowment for the Arts.

Produced by the Department of Publications
The Museum of Modern Art, New York
Osa Brown, Director of Publications
Edited by Christopher Lyon
Designed by Emily Waters
Production by Amanda W. Freymann
Printed and bound by Tien Wah Press, Singapore

Library of Congress Catalogue Card Number 95-75008
ISBN 0-87070-161-4 (The Museum of Modern Art)
ISBN 0-8109-6148-2 (Harry N. Abrams, Inc.)

Distributed in the United States and Canada by Harry N. Abrams, Inc., New York
A Times Mirror Company

Distributed outside the United States and Canada by Thames and Hudson Ltd., London

Printed in Singapore

Unless otherwise noted, all art works illustrated are by Annette Messager, courtesy Galerie Chantal Crousel.

COVER: The Pikes (Les Piques). *1991–93. Parts of dolls, fabric, nylons, colored pencils, colored pencil on paper under glass, and metal poles. Musée National d'Art Moderne, Centre Georges Pompidou, Paris; and collections Michael Harris Spector and Dr. Joan Spector, and the artist.*

ENDPAPERS *(front):* On the Bedroom Works—A Double Life? (Sur les travaux de la chambre—une double vie?); *(back):* The Bedroom Works/The Studio Works (Les Travaux de la chambre/Les Travaux de l'atelier). *1973. Ink on paper. Collection the artist.*

FRONTISPIECE: *Detail of* My Vows (Mes Voeux*). 1988–91. Gelatin-silver prints under glass, and string. The Museum of Modern Art, New York. Gift of The Norton Family Foundation.*

PHOTOGRAPH CREDITS: *Alinari/Art Resource, NY, fig. 44; Hickey-Robertson, Houston, fig. 52; Kate Keller, fig. 53; courtesy Galerie Laage-Salomon, fig. 38; Peter MacCallum, courtesy Mercer Union, Toronto, figs. 14, 18, 27 and 28; Mali Olatunji, figs. 35 and 45; © Photo R.M.N., fig. 39; Adam Rzepka, cover and fig. 13.*

Acknowledgments

Annette Messager's

Carnival of Dread and Desire

Sheryl Conkelton

"Nourishment You Take"

Annette Messager, Influence, and the

Subversion of Images

Carol S. Eliel

Acknowledgments

In 1991 Annette Messager was approached about an exhibition at the Los Angeles County Museum of Art by Carol Eliel, in the museum's department of twentieth-century art. Soon afterward, Sheryl Conkelton, then in the museum's department of photography, independently began to consider an exhibition of Messager's work. When we discovered our common passion, the shared idea quickly became an interdepartmental project. After Conkelton joined the staff of The Museum of Modern Art, New York, and with that museum's institutional participation, the collaborative project was born.

When we began, Messager's work had not been widely seen in the United States and neither of us could have imagined this important institutional collaboration. Since then, Messager has gained attention in this country for the few works that have appeared in important group exhibitions such as *Parallel Visions* at the Los Angeles County Museum of Art (co-organized by Carol Eliel) and *Corporal Politics* at the MIT List Visual Arts Center in Cambridge, Massachusetts. Her career as a whole, however, and the forces that have shaped it, still have not been investigated in depth here. We are pleased and honored that the two institutions, with important international sponsorship, can present this first retrospective of Messager's work in the United States.

Above all we thank Annette Messager, who has been involved and supportive every step of the way. Not only is her art visually and intellectually rich and endlessly rewarding, but she is *sympathique* in the fullest sense: understanding, congenial, a pleasure to work with. Her enthusiasm, her quiet strength, and the depth of her insights are exemplary.

Many others, both in France and in North America, have contributed to the success of this exhibition. We particularly thank Jean Digne, director of the Association Française d'Action Artistique; his associates Max Moulin and the late Gérard Guyot; Jacques Soulillou of the French Cultural Services in New York; and Jean-Claude Terrac and Béatrice Le Fraper du Hellen, the former and present cultural attachés, respectively, in the French consulate in Los Angeles. Without their support and assistance, this exhibition would not have come to fruition. We also gratefully acknowledge the support of the National Endowment for the Arts. Air France helped support the artist's travel to each of the exhibition venues.

Messager's dealer in Paris, Chantal Crousel, was ever helpful, as was Francine Tagliaferro of the Galerie Chantal Crousel. Tracy Williams, formerly of the gallery, was a constant source of information and enthusiasm. In this country, Paule Anglim, Ruth Bloom, and Rhona Edelbaum were generous with their assistance. We also thank Marie-Claude Beaud, Christian Boltanski, Emily Braun, Jim Drobka, Barbara London, Joseph Newland, Yvette Padilla, Béatrice Parent, Amy Richlin, Anne Rochette, Robert Storr, Mitch Tuchman, and Lynn Zelevansky for support and assistance of many kinds.

Numerous colleagues at the two institutions helped make this exhibition a reality. In the museums' development departments, Tom Jacobson in Los Angeles and Daniel Vecchitto and John Wielk in New York helped secure funding. In the departments responsible for exhibition programs, John Passi in Los Angeles and Richard Palmer and Eleni Cocordas in New York coordinated the complex logistics. Registrar Renée Montgomery in Los Angeles carefully arranged shipping for the exhibition and its tour; Diane Farynyk supervised the exhibition in New York. Research and other kinds of assistance with the catalogue were provided by Roz Leader in Los Angeles and Sarah Hermanson, Tanya Murray, and Yuri Tsuzuki in New York. We appreciate the important support of librarians Anne Diederick at the Los Angeles County Museum of Art and Janis Ekdahl

and Eumie Imm at The Museum of Modern Art. The sensitive installation designs, created by Bernard Kester in Los Angeles and Jerry Neuner in New York, were carried out in Los Angeles by Art Owens and his staff and in New York by Pete Omlor and the exhibitions staff of the department of registration. In Los Angeles, Pamela Patrusky skillfully designed the installation graphics and Lisa Vihos coordinated didactic materials and educational events related to the exhibition. For their attention to the conservation and safety of the art we thank Victoria Blyth-Hill in Los Angeles and James Coddington, Antoinette King, and Karl Buchberg in New York. Public information directors Barbara Pflaumer in Los Angeles and Jessica Schwartz in New York and their respective staffs ably and enthusiastically publicized the exhibition. The department of publications at The Museum of Modern Art was responsible for the production of this catalogue. We thank Osa Brown, director, and Harriet Schoenholz Bee, managing editor, for their guidance. The clear and readable text is due to Christopher Lyon's thorough editing, and Amanda W. Freymann skillfully handled the production. For the sensitive and beautiful design of this book we are indebted to Emily Waters.

We are especially grateful to colleagues in our respective departments for sharing our excitement and providing advice and support: Stephanie Barron, Howard Fox, Eric Pals, Rachel Simon, Nina Berson, and Jennifer Yates in the department of twentieth-century art of the Los Angeles County Museum of Art; and Peter Galassi, Susan Kismaric, Thomas Collins, Jennifer Liese, and Aimee Samuels-Majoros in the department of photography of The Museum of Modern Art. We particularly thank director emeritus Richard E. Oldenburg and director Glenn D. Lowry of The Museum of Modern Art, deputy director James Snyder, and Stephanie Barron, serving as coordinator of curatorial affairs at the Los Angeles County Museum of Art, for their support and assistance in the collaboration between the two institutions. At the Los Angeles County Museum of Art, The Modern and Contemporary Art Council provided funding for the artist's initial visit to Los Angeles to discuss exhibition possibilities.

The participation of The Art Institute of Chicago extended the exhibition geographically and enabled it to reach many more viewers. We thank associate curator of photography Sylvia Wolf for her spirit of collaboration, and director James Wood and assistant director Dorothy Schroeder for their support in bringing Messager's work to Chicago.

Finally, Annette Messager joins us in acknowledging the lenders, listed on page 94, who kindly permitted us to borrow work for the exhibition. Their generosity allowed us to present the extent of Messager's achievements, and we thank them for making this possible.

Sheryl Conkelton
Associate Curator
Department of Photography
The Museum of Modern Art, New York

Carol S. Eliel
Associate Curator
Twentieth-Century Art
Los Angeles County Museum of Art

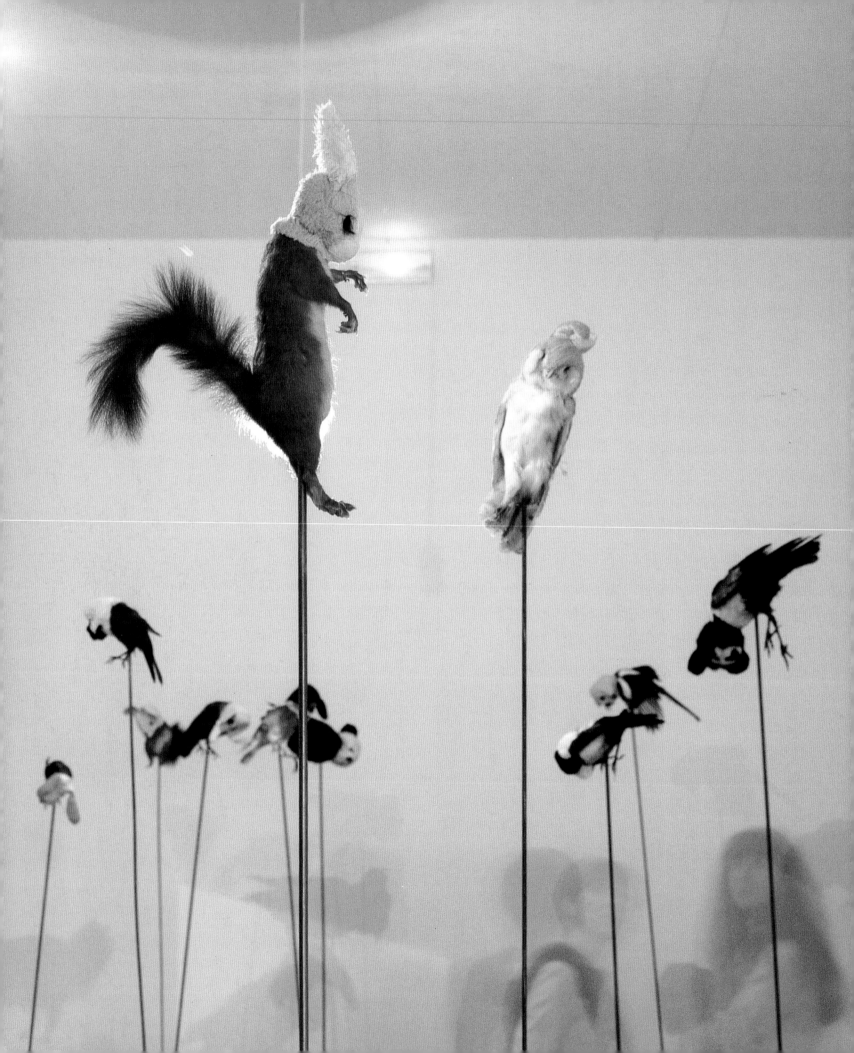

Annette Messager's Carnival of Dread and Desire

Sheryl Conkelton

THE ARTWORK OF ANNETTE MESSAGER refuses categorization on every level. Over the last twenty-five years, she has employed myriad materials and methods, pursued wide-ranging conceptual explorations, and consistently pushed against artistic boundaries. Messager is interested in how collective representations and social constructs may be altered and in their transcendence through individual interpretation. She dismisses the idea that her art is political, but she is preoccupied by relationships of power and their perpetuation through a culture's imagery.[1] She strategically ignores the proprieties and social categories that maintain established powers; her art—which alternates between quiet, almost religious reverence and wild, often sexual escapade—conjures a visiting carnival in which normal life is disrupted and all expectations are turned upside-down.

The metaphor of the carnival, first explored by Mikhail Bakhtin in his analysis of the writings of Rabelais, aptly applies to Messager's art.[2] The carnival, originally a celebration of the changing of the seasons and the transformation of land and people, partly religious, partly agricultural, evolved into a traveling caravan of midway games, entertainers, and tricksters whose appearance marks the suspension of normal routines. In the carnival's recent history, its denizens are often freaks, creatures both deformed and special, often with macabre skills that frighten even as they entertain. Carnival means extraordinary disruption: strange beings are encountered and spectacles are witnessed. The transgressive aspect of the carnival is significant: its inclusion of all types of creatures and behavior and its suspension of normal rules blur the lines between civilized and uncivilized behavior; for the few days the carnival is in town, anarchy reigns. The senses are overloaded by the surreal, the rational is denied, things become other things.

LEFT: *1.* Nameless Ones (Anonymes). *1993. Installation view, Biennale d'Art Contemporain, Halle Tony Garnier, Lyon, 1993. Twenty-three taxidermized animals with stuffed animal heads, gelatin-silver prints under glass, and metal poles in clay bases. Collection contemporaine du Musée Cantini, Marseille.*

RIGHT: *2. Detail of* The Pikes *(see fig. 23).*

9

Messager's art, which borders on the cartoonish and vulgar in many series, is carnivalesque: unabashedly, consistently, and pointedly anarchistic in its insistence on abandoning rationality. It is whimsical yet deeply political in its commitment to anarchy over enlightenment as a means to recognize, create, and possess the self. Messager's inclusive, nonjudgmental, nonhierarchical approach to materials, methods, and sources is intended to displace, dislodge, and diffuse power even while it seduces and entertains; its carnival is a celebration of revolutionary spirit and individual power.

Messager's array of materials includes photographs (hers and others), paint, metal, found objects, colored pencils, books, embroidery, crayons, toys, and taxidermized animals (figs. 1 and 2). Her intermedia and conceptual approach does not follow established hierarchies of artistic means but encompasses art and non-art modes: painting, sculpture, assemblage, collage, cinematic montage, and writing. Just as varied, her sources include Symbolism and Surrealism, how-to books, magazine and newspaper articles and advertisements, astrology, religious art, *art brut*, eighteenth- and nineteenth-century literature, Alfred Hitchcock, William Blake, Odilon Redon, and Jean Genet. Messager deliberately disregards accepted meanings and mixes sources and forms, discovering in her material play a conceptual anarchism in which ideologies are set aside: "Conceptual art interested me in the same way as the art of the insane, astrology, and religious art. It's not the ideologies which these areas perpetuate that interest me: they are for me, above all else, repertories of forms. I make fun of sorcery and alchemy even if I make full use of their signs."[3]

This unorthodox approach to art is radically skeptical and skeptically radical; her contradictory aesthetic directly challenges art's conventions, but not from a single, polemical perspective. She refuses to differentiate between high and low forms of art, and her mixing of sources and mediums opens up the order of art to the disorder of life. She ignores the rules of both art and life and builds instead upon the depth and texture achieved in the amalgamation of the two.[4] In her unconventionality and challenges to the status quo, Messager is very much part of an international, postmodern generation of artists who began working in the 1960s and who challenge the idea of art as avant-garde invention, opposing its separation from nonartistic concerns. Artists such as Marcel Broodthaers, the Fluxus group, and Joseph Beuys, inspired by Marcel Duchamp, interrogated the concept of art as an isolated endeavor. They built their own art less on artistic models of the past than on philosophic questioning of accepted conventions of artistic activity and representation, and their ideas laid a foundation for their generation's conceptual art.

In France, Messager's peers and friends included the artists Jean Le Gac, Paul Armand-

Gette, Sarkis, and Christian Boltanski.[5] They worked together, were shown as colleagues, and at times collaborated on projects.[6] They came of age amidst the social discontent of France in the late 1960s, a period of great disorientation that prompted one student chronicler to write, "Something has tipped over in our universe. Two and two do not quite equal four any longer. We are being impregnated by a certain new shifting of ideas, of sensations."[7] The May 1968 student rebellion began at the University of Nanterre and quickly spilled over into Paris, in the Latin Quarter and at the Sorbonne. Many of the leaders of the student revolt had been involved with the Situationist International of 1957, a libertarian movement that advocated violent and poetic resistance to what was prescribed.[8] All universal values were suspect, and defiant practices were naturally adopted from earlier artistic movements that countered modernism's utopianism, humanism, and rationalism. In their refusal to submit to rational processes and their insistence on dislocating orders, the various Surrealist practices were seen as exemplary oppositional methods and were adopted as central revolutionary strategies.[9] Also significant were new ideas coming from philosophers and social critics such as Guy Debord, Roland Barthes, and Michel Foucault, who began to reinterpret the great modern thinkers, especially Marx, Freud, and Sartre. Debord and the others were interested in the structure of society, from the dynamics of politics and economics to the functions of language and visual representation, and much of their work was devoted to critical examination of cultural institutions. This political and social milieu had a profound impact on the student generation and on the work produced by Messager and her friends, prompting her to remark, "In France there isn't conceptual art in the strictest sense of the term. The thinking behind mélange and hybridization . . . comes to us from May 1968."[10]

In her early work, Messager satirized the arbitrary compartmentalization of social hierarchy by dividing her own activities into two groups, those done in the bedroom of her small apartment and those done in the studio. In the bedroom, Messager assembled collections of images and objects, appropriating, creating a new order, and integrating information into her own systems; she signed these works "Annette Messager Collectionneuse." In the studio, she fabricated objects and made her art, signing those works "Annette Messager Artiste." Her division was a critique of the separation of art and life—the bedroom collections were clearly artworks as well, and were exhibited as such—and this act was a challenge to any arbitrary principle of definition, such as geographical location or gender. The dividing up of her activity has counterparts in other dichotomies, which it was intended to evoke: nature/culture, male/female, intellectual/emotional, high/low. The recognition of these dichotomies thrust the decision-making and conceptual aspects of art-making to the

fore; in her apparent playfulness, Messager exposed the a priori thinking and the processes of categorization that are central to the interpretation of art.

In the studio in 1971 and 1972, "Annette Messager Artiste" produced a series of works that featured "boarders" (*pensionnaires*) in various activities. These creatures boarding in her studio were taxidermized sparrows that she subjected to certain actions. In *Boarders at Rest* (*Le Repos des pensionnaires*) (1971–72; fig. 3), dozens of them are laid out in little knitted sweaters, as if sleeping peacefully, while in another work several are tied to metal contraptions, in an enactment of corporal punishment. The use of the animals in tableaux suggests the often sadistic play of children, in which smaller things are made to act in imaginary situations. Their stilled presence is a result of both her "discipline" of the creatures and their taxidermized state. The use of taxidermy is related to her later interest in and use of photography, in that both taxidermy and photography freeze motion and extend presence, as she has pointed out.[11] This combination of materials (little feathered corpses in awkward knitted clothes), simple techniques, and minimal work that "a child could do" commented wryly on the elevated status of the art object. It also foretold the paradoxical nature of Messager's consistent and deliberate presentation of multiple, apparently contradictory, positions on any issue. In her refusal to choose or espouse only one, Messager is both the childlike naif that the romantic notion of an artist would have her be and the intellectual and sophisticated conceptual artist who insists on the viewer's self-conscious participation.

"Annette Messager Collectionneuse" assembled collections in the form of a numbered sequence of fifty-six scrapbook-style albums, made from about 1971 to 1974. The first album-collection was *The Marriage of Miss Annette Messager* (*Le Mariage de Mlle Annette Messager*), whose form was taken directly from the non-art, commemorative tradition of marriage albums. Messager cut wedding notices from newspapers and pasted them into the album, substituting her own face and name for those of the brides. Subsequent albums include chronicles of rites of passage in "her" life, which feature every sort of diaristic indulgence: *Nine Months in the Life of Annette Messager* (*Annette Messager pendant neuf mois*), *Everything about My Child* (*Tout sur mon enfant*). Some albums consist of lists and small drawings, like the *Handbook of Everyday Magic* (*Petite Pratique Magique quotidienne*) (figs. 4 and 5); altered photographs, as in *Children with Their Eyes Scratched Out* (*Les Enfants aux yeux rayés*) (figs. 6 and 7); cut-out illustrations from women's magazines; and fantasies of sexual adventure. A number include how-to illustrations and diligently

3. Detail of Boarders at Rest (Le Repos des pensionnaires). *1971–72. Taxidermized birds and wool. Collection the artist.*

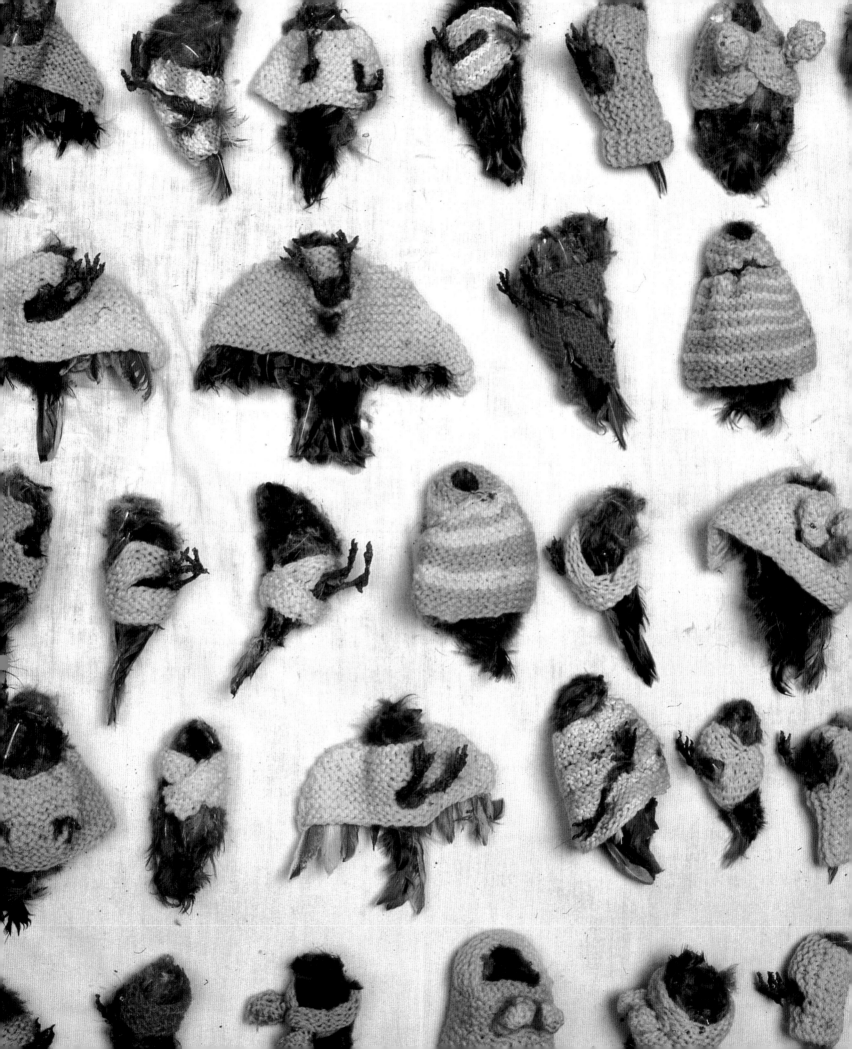

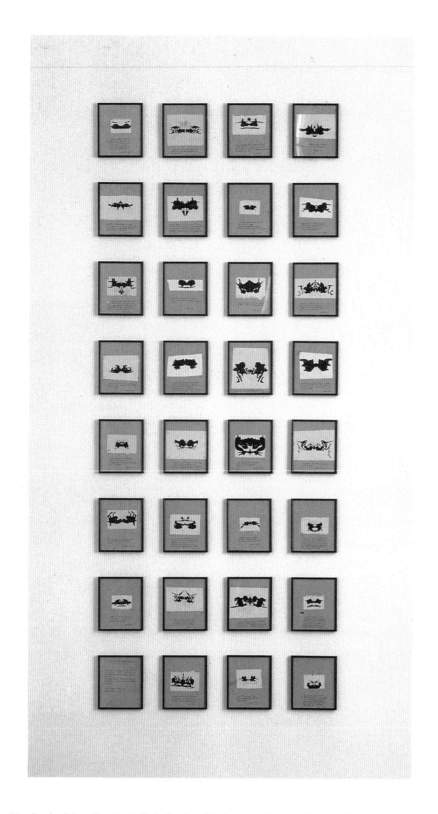

4. Handbook of Everyday Magic (Petite Pratique Magique quotidienne), Album-collection No. 47. *1973.*
Thirty-two mixed-medium on paper elements (album not pictured). Courtesy Galerie Chantal Crousel, Paris.

copied instructions: *My Guide for Knitting* (*Mon Guide du tricot*), *Practical Life* (*La Vie pratique*). Some show her attempt to perfect herself: *Collection to Find My Best Signature* (*Collection pour trouver ma meilleure signature*) (see fig. 34), *Women I Admire* (*Les Femmes que j'admire*); others communicate her frustration over the limitations and demands of the roles dictated for women by society: *Before and After* (*Avant-Après*), *Qualifications for Being a Woman* (*Les Qualificatifs donnés aux femmes*). Mixing the personal and the cultural, Messager articulated the contradictory impulses to emulate models that represent maturation and socialization and to resist that process of assimilation. Reflecting the variety of the types of material represented in the collections,

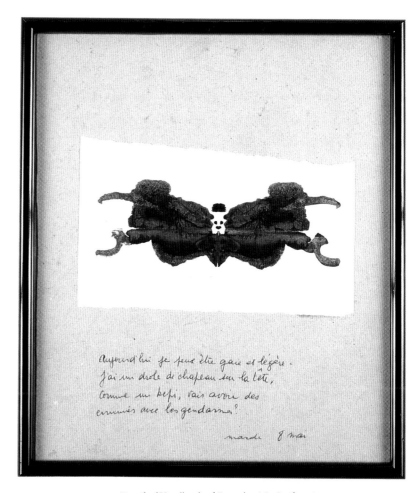

5. *Detail of* Handbook of Everyday Magic *(fig. 4).*

Messager added new personae to the ones she had already established: in addition to *artiste* and *collectionneuse*, she began to call herself *femme pratique* (practical woman), *colporteuse* (peddler), and *truqueuse* (trickster).

A subgroup within the album-collections consists of collections of images in which women are cast as objects of violence. In *Voluntary Tortures* (*Les Tortures volontaires*) (1972; fig. 9), Messager assembled clipped illustrations of women submitting to beauty treatments, ranging from mud baths and facial peels to more painful and radical plastic surgeries. The strange contraptions, awkward positions, and re-formed body parts graphically illustrate the sacrifice of individual identity to a socially defined standard of beauty. As part of the process of assembling *The Horrifying Adventures of Annette Messager, Trickster* (*Les Effroyables Aventures d'Annette Messager truqueuse*) (1974–75; fig. 10) and *My Clichés* (*Mes Clichés*) (1976–77), Messager made drawings after illustrations in pornographic magazines

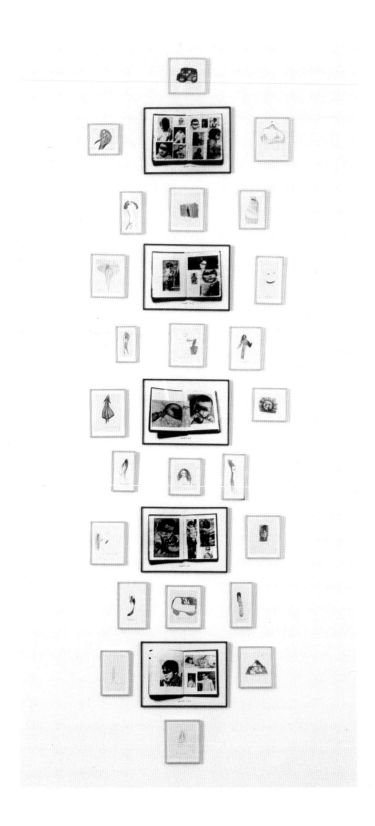

6. Children with Their Eyes Scratched Out (Les Enfants aux yeux rayés), Album-collection No. 3, *1971–72,*
and My Children's Drawings (Mes Dessins d'enfant), Album-collection No. 5, *1972.*
Ink on five gelatin-silver prints and twenty-four colored pencil on paper drawings (albums not pictured). Musée d'Art Moderne de la Ville de Paris.

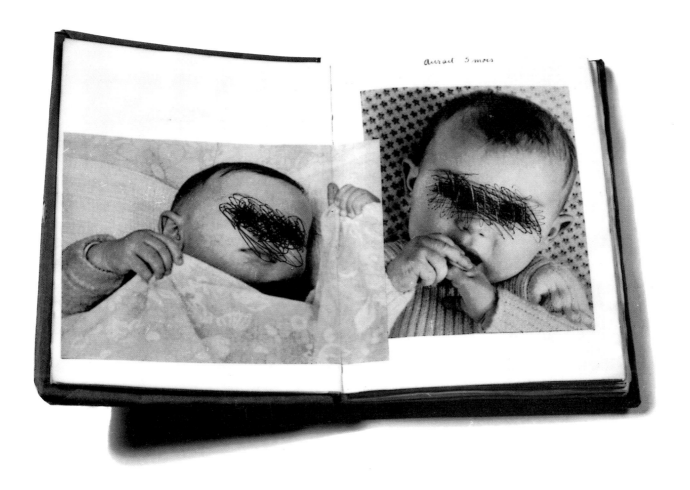

7. Children with Their Eyes Scratched Out *(album)*.

of women as victims of sadomasochistic and sexual violence. In both works, Messager took over the images by drawing them in her own hand, thus seeming to acquire these pulp fantasies as incidents in her own experience. In so doing, she actively reconstructed images in which women are presented as objects. By redrawing them in a rote, mechanical way (and even, in *Horrifying Adventures*, distancing them further by photographing her drawings), she overwrote the original meaning in styleless and impersonal replication. Assuming that all or most of this pornography was created by men, Messager's act of recreating it as a woman throws the purpose and meaning of the images further into question.

These images epitomize a social formulation of the female body that dictates passivity.[12] Although Messager would not identify herself as a feminist during this period, she was very much aware of the threat to her freedom and her identity as an individual—a female individual—posed by the roles and behavior prescribed for women by society. She felt the art

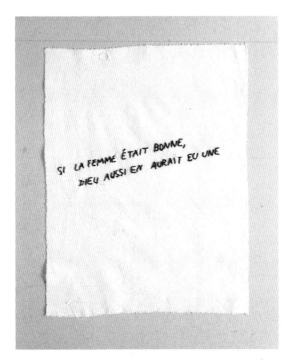

8. *"If woman were good, God would have had one" (above) and "Women are taught by nature, men by books" (right), details from* My Collection of Proverbs *(Ma Collection de proverbes). 1974. Fabric and thread. Collection the artist.*

world to be a very masculine place, with male codes and privileges that would be difficult to transcend.[13] In the context of early 1970s feminism, the objects of her appropriation and her particular style are interesting and unusual.[14] Her use of unheroic practical arts, such as embroidery, and her method of repetitive copying seemed to embrace the then-dominant idea of the feminine, but her subjects often contradicted this easy equation: rather than challenge social definitions with separatist feminist imagery, Messager defiantly appropriated images of male fantasy and pornography that were meant to be segregated from women. By copying such images exactly, she could capture them as her own and combine them at will—in her own words, "displace rather than change, rather than submit." Her own strategy began to evolve, not as a presentation of oppositional dogma but as a subversive, intensely personal resistance to categorization.

Messager's interest in the effects of displacement can be seen in her play with language. *My Collection of Proverbs (Ma Collection de proverbes)* (1974; fig. 8) is a group of crude embroideries that display traditional French folk sayings, which typically appear on such objects as ashtrays, wine pots, and coffee mugs.[15] All are derogatory, jokey aphorisms and colloquialisms about women: "If woman were good, God would have had one"; "Women are taught by nature, men by books"; "Three girls and their mother, four demons for their father"; "The eye of a woman is a spider's web." Messager saw these proverbs as interdictions that control and even forbid certain behaviors of women. Her strategy was not to replace one aggressive language with another, but to substitute in place of an authoritarian mode of discourse a less proscriptive one. Again, by rearticulating these anti-female messages in a feminine medium, she wrestled them from the original context and dislodged the original intention. This

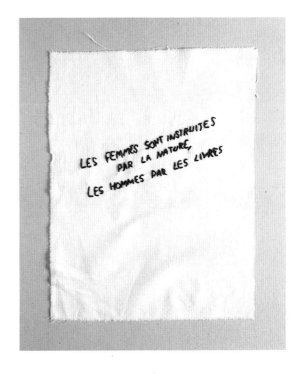

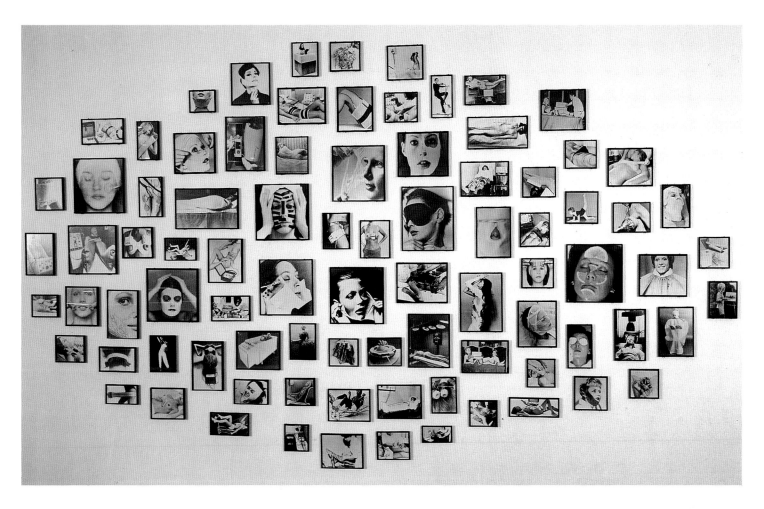

9. Voluntary Tortures (Les Tortures volontaires), Album-collection No. 18. *1972. Eighty-six gelatin-silver prints (album not pictured). Fonds Régional d'Art Contemporain, Lyon, France.*

discursive play and shifting of contexts quietly challenges the authority of a single and absolute meaning. Messager has cited *Tristes Tropiques* by French anthropologist Claude Lévi-Strauss as an important influence on her understanding of language. The central thesis of this semiautobiographical work is that the function of linguistic meaning erupts from its context and reflects the same concepts, prejudices, and myths that inform the social structure containing it. The structuralist emphasis on context and the consequences of shifting contexts has continued to play a significant part in Messager's work.

Messager also recognized the value of photography in creating new contexts and a sense of displacement for the viewer. In her early works she used found photographs in the assembly of her collections. In the late 1970s she began to create large works using her own

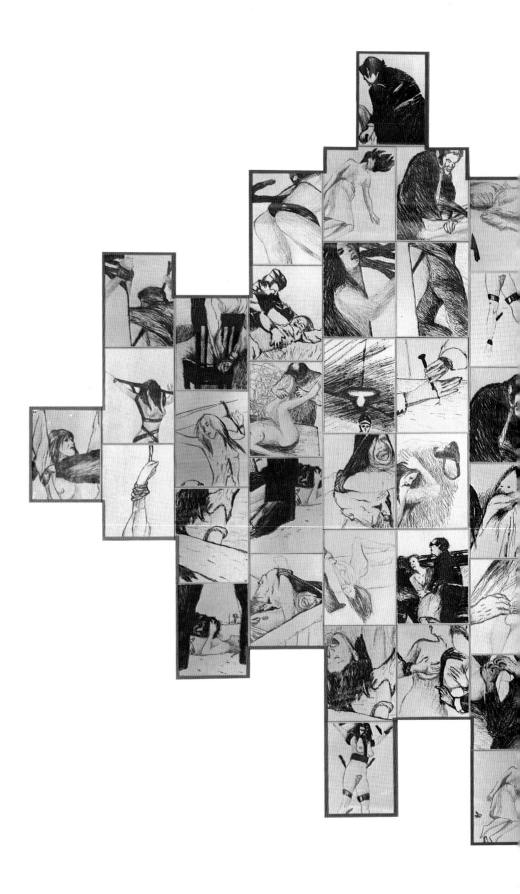

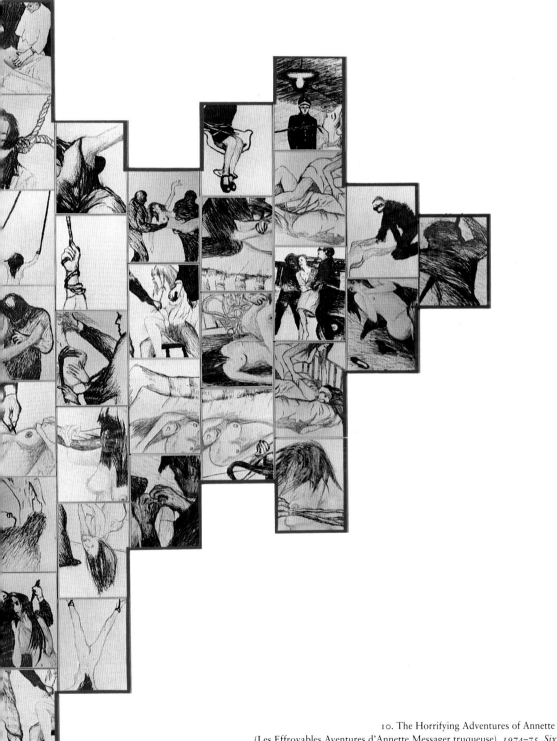

10. The Horrifying Adventures of Annette Messager, Trickster
(Les Effroyables Aventures d'Annette Messager truqueuse). *1974–75. Sixty-four gelatin-silver prints, mounted and framed.*
Collection the artist, courtesy Galerie Chantal Crousel, Paris.

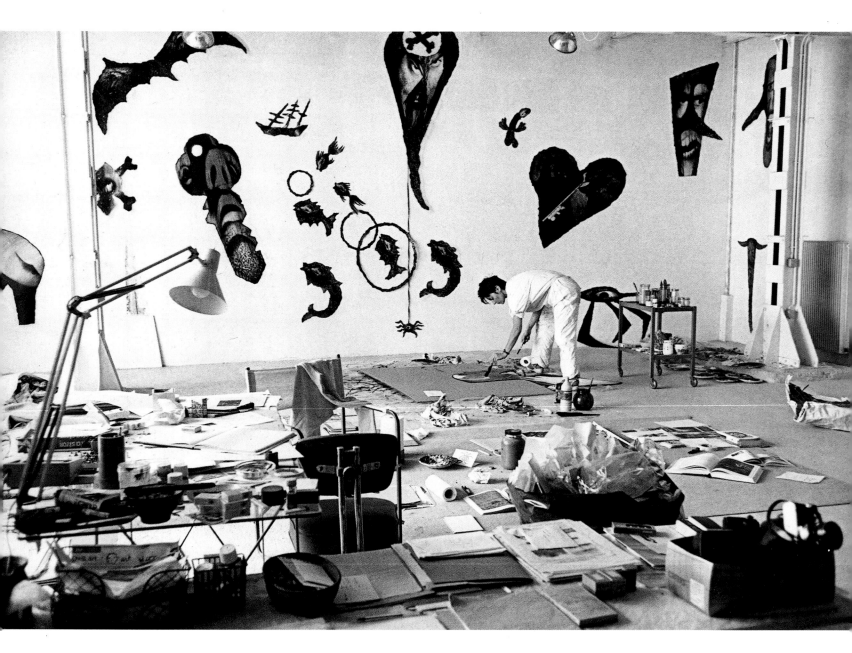

11. View of Messager's studio with Chimaeras, *Malakoff, France, c. 1982.*

photographs, employing photography's ability not only to replicate a subject precisely but also to replace one that is no longer present, creating a fetish. Messager values this transformative quality, and she has pointed out that our conceptualization of photography, including the way it is described—*"bain d'arrêt, fixative, révélateur, la chambre noire"* (stop bath, fixer, developer, darkroom)—acknowledges its magical, fetishizing characteristics.

In 1982 Messager incorporated this sense of magic in her series *Chimaeras (Chimères)* (figs. 11 and 12, and see figs. 40, 42, and 43), large photographic composites that take the shapes of monsters. Chimaeras are imaginary hybrid creatures, most often given a female personality or identity. Messager's own photographs of detached body parts were combined to form witches, bats, bare and twisted trees, huge spiders, and oversize banal objects, such as scissors and keys, whose giganticism is threatening. Painted with bright colors, installed in dense, strange vignettes, the monsters menace each other across an exhibition space even as the component images within their outlines fight each other. A large penis overwhelms frightened eyes inside the shape of a cartoon moon; scissors chase bats across a wall. These installations are lurid and luxurious, oversize, overpainted, overtheatrical; they breach decorum and violate the integrity of both painting and sculpture with a hysterical disorder.[16] They appear to be female desire gone horribly wrong: cobbled-together witches, hybrid monsters; castration fantasies abound in a celebration of *la bête noire*—the dark (female) beast. They are grotesque not only in their subjects but also in their mixing of various entities in dangerous, unstable conglomerates in which reality and fantasy become confused.[17]

Discerning the nature of the composite parts requires careful looking; the *Chimaeras* attract and repel at the same time. Inside the outlines of creatures that seem to belong in fairy tales are images of human parts, engorged, distended, horrible in their extreme gestures. Like Alfred Hitchcock, Messager subverts our trust in ordinary things by enlarging them to monstrous proportions.[18] Her method recalls the writings of Bruno Bettelheim, which she admires: he asserted that fairy tales have a psychological function for children; they gain an understanding of the world not only through rational comprehension of it but by imaginary experience.[19] Messager mixes up ordinary objects with fairy-tale concoctions like the Man in the Moon and mythical characters such as the weaver Arachne to create a visual fantasia that cannot be interpreted rationally.

In a group of works made from 1986 to 1988 titled *My Trophies (Mes Trophées)* (fig. 13 and see fig. 50), Messager turned again to the less-regarded arts of tattooing, palmistry, chiromantic manuals, and children's books, as well as to the illuminated initials of medieval manuscripts. She created photographs of body parts and drew over them whimsical figures,

arcane symbols, and decorative marks. These works, perhaps mementos from love or war, appear to represent fragments of bodies, estranged and transformed through drastic changes in scale. Whether large and hung up high on the wall, tipping outward to loom over the viewer, or tiny and precious and hung near eye level, they are removed from immediate experience. Some are transformed into other things: buttocks appear to be a death's head, a nose a small hut, the palm of a hand a landscape. Each becomes an object of curiosity or devotion; reminiscent of reliquaries or ex-votos, they are points of departure for reverence and reverie, curious meditations on physicality and transformation.[20]

The series that directly followed, *Lines of the Hand* (*Les Lignes de la main*) (1987–88; fig. 14), also consists of photographs of body parts pictured close up and enlarged, covered with arcane figures. These images are firmly anchored, set on top of pillars of repeated words written directly on the wall in colored crayon. In this series the words are no longer on the images; the shift of location is subtle, almost as if the unspoken names of the figures within the image had moved out onto the wall. The words, from a list created and maintained by Messager, refer to states of emotional revelation: trust, protection, hesitation, fear, rumor (*confiance, défense, héstitation, crainte, rumeur*). The word she has chosen to accompany a particular image is repeated down the wall from the image to the floor. As with the verbal repetition of a word over and over, the reiteration on the wall drains meaning from it, reducing the words to mere form; they become instead elements of ritual architecture, visually supporting the images.

In the series of installations *My Works* (*Mes Ouvrages*) (1987; fig. 15 and see fig. 51), Messager connected her images with strings of words written in colored pencil on the walls; the installation recalls calligraphic poems as well as maps. The words here are drawn from amorous language in its various tones and moods. Such words may be tender, anxious, even dangerous, evoking the same kind of ambiguity that ties intense happiness and arousal to madness and death.[21] *My Works* diagrams intense feeling instead of portraying it outright. Again, Messager deliberately introduced a critical and self-aware distance: the work is a gloss or commentary on emotion rather than a representation of it, a playful game that nonetheless has poignant and even painful moments of self-recognition. Much of her work creates this palpable distance, in which the viewer becomes aware of the artist's self-consciousness and deliberation and recognizes the constructed nature of even the most intimate communications. Although an installation of *My Works* resembles a map, the personal and hermetic nature of Messager's terrain may preclude the document's usefulness; the map is offered, but ultimately cannot be followed.

12. Chimaeras (Chimères). *1982–84. Installation view, Mercer Union, Toronto, 1991.*
Acrylic and oil on gelatin-silver prints mounted on mesh. Collection the artist.

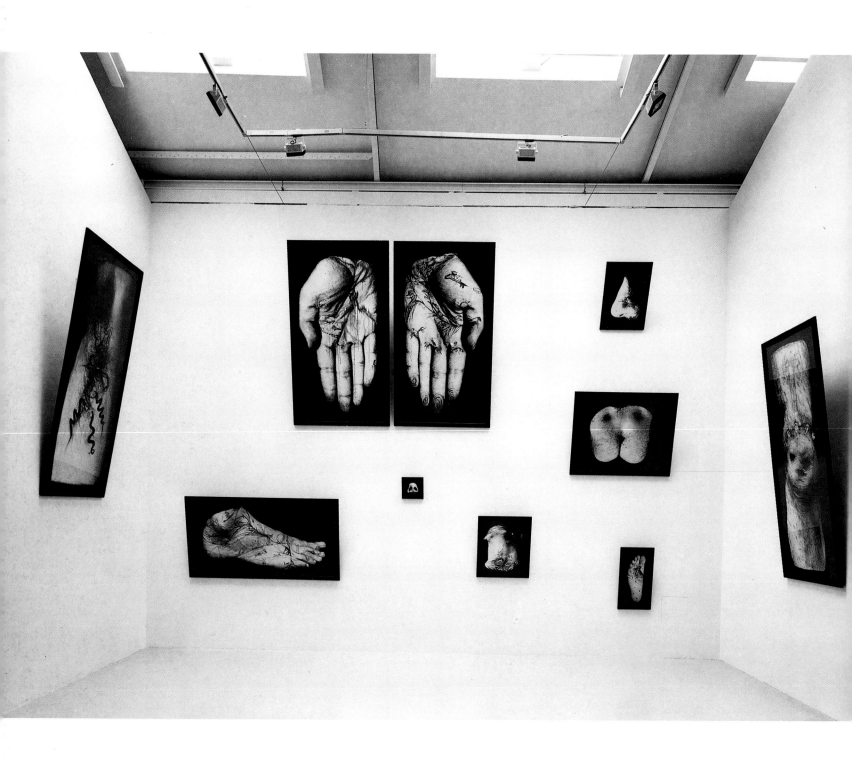

13. My Trophies (Mes Trophées). *1987. Installation view, Galerie Laage-Salomon, Paris, 1988.*
Acrylic, charcoal, and pastel on gelatin-silver prints with wood frames. Various collections.

In the series *My Vows (Mes Voeux)* (figs. 16 and 17, and see fig. 56), begun in 1988, Messager presented fragments of body parts in small photographs that she clustered on walls in dense arrangements. The photographs resemble the ex-votos and devotional offerings found in chapels and pilgrimage places: each image shows only a fragment and is attached to the wall with a length of string. There is much punning in the concept and construction of these works, recalling Messager's earlier involvement with language, particularly colloquialisms. The French word *voeux* names the votive tablets placed in chapels but also means "vows."[22] The string used to suspend the images makes numerous references: the word for string, *ficelle*, appears in a number of French colloquialisms that have double meanings: *bien connaître les ficelles* means "you know well," *bien ficelle* means "well put together," and *en ficelle* means "relayed through" or "displaced." Messager intends the viewer to play with these possible meanings of the strings, to amplify the formal appearance of the work with this discovered linguistic significance.

Isolated body parts are pictured in the individual photographs that compose *My Vows*; hung in a group, the images do not constitute one body but a mix of bodies: old and young, nurturing and indifferent, aroused and at rest, male and female. This deliberate confusion of identity is a powerful incantation: the interpenetration of different physical entities is surreal, and the coherent whole suggests a psychological state in which gender is elusive and interchangeable. Jacques Lacan's view of sexuality, in which gender is not a given but is constructed just as other components of our human identity are, informs these works, which shift and change as the viewer's eye wanders over the array.[23] Discussing Lacan's view, John Rajchman has noted, "There is a basic incompatibility between love and sexuality. Sexuality is traumatic as such. . . . It is not a matter of happiness and pleasure but of the uncanniness or otherness of desire. It refers us not to our common essences, but to our constitutive 'lack' of one."[24] The fragmentation of the body in *My*

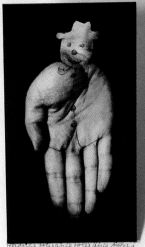

14. Lines of the Hand ("*Tolerance*") (Les Lignes de la main ["*Tolérance*"]). 1988. Acrylic, charcoal, and pastel on gelatin-silver print, framed in wood, and colored pencil on wall. Weil, Gotshal & Manges.

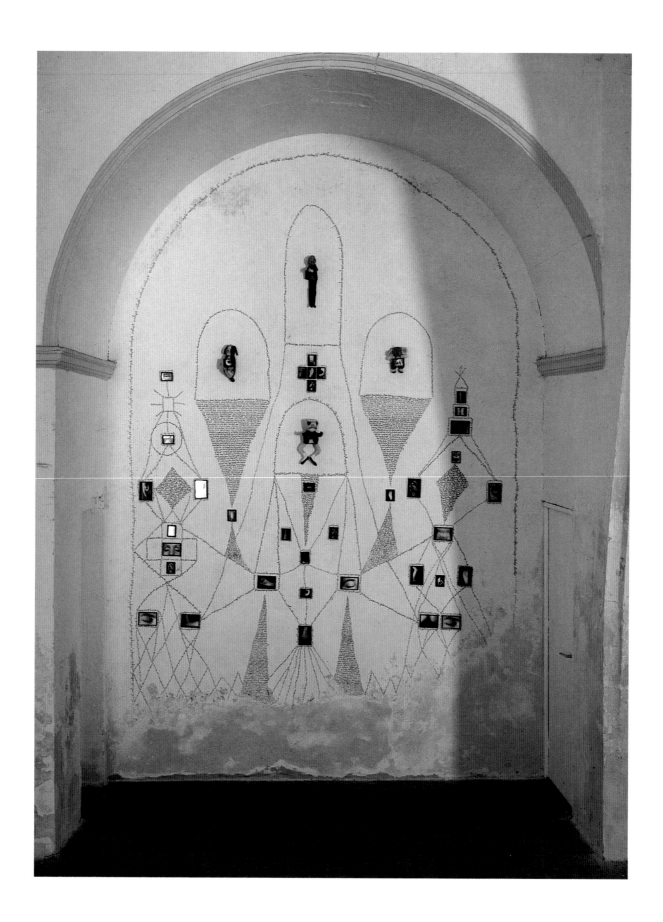

Vows can also reflect the traumatic nature of sexuality and the loss of self in the act of sex. In French, *petite morte*, literally "small death," refers not only to a seizure or fit but also to the climax of the sex act. By isolating details of the body, Messager deliberately betrays romance and emphasizes the danger of love's entanglements.

Beginning in 1987, Messager worked with arrangements of used stuffed toys, combining them with black and white photographs of body parts and bits of text in works titled *The Story of Little Effigies* (*Histoire des petites effigies*) and *My Little Effigies* (*Mes Petites Effigies*) (figs. 18–20). Most often these works were shown in installations, with the animals scattered across a wall, each necklaced with a photograph and shadowed by a word repeatedly crayoned on the wall below. Some of the figures were blindfolded, intimating loss of sight and, combined with their strung-up appearance, even torture. The use of toys again recalls the paradoxical nature of children's ideas about relationships with playthings, combining beloved familiarity and a creeping sadism. Messager is interested in this paradox, but where stuffed animals can often symbolize a darker, masturbatory childhood, replete with forbidden activity (for example, in the work of Mike Kelley), Messager's stuffed animals recall a broader range of childhood playacting and ritual.[25] Her animals are ambivalent: they can be talismans of youthful invention as well as the discarded accomplices of a maturing child who has discovered and attempted to demystify desire.

In a 1989 exhibition, Messager interspersed *My Little Effigies* with African sculpture lent from an ethnographic collection (fig. 20).[26] She hung her stuffed animals on the walls, isolated and precious, imitating the presentation of a museum installation of African objects. Despite differences in manufacture and material, the two kinds of effigy coexisted well, each alluding to rites of passage in their respective cultures. Messager was struck by the responses to her invasion of a museum collection, and she has recounted the contrasting comments of two women. One very much disliked the installation, remarking that her son had the very same toys and that such things did not deserve to be hung in a museum, but another woman, who better understood how the objects function as fetishes, thought it was "good to see these puppets here [with these sculptures] because they are the same." Messager draws attention to the magical qualities of objects used in Western societies so that they may recoup some of the status and even magic of objects used in rituals in other parts of the world.

These works also demonstrate Messager's abiding interest in the combination of different types of representation. The black and white photographs attached to the stuffed animals propose a different kind of being, often out of scale and without any apparent relationship

15. My Works (Mes Ouvrages). 1987. Installation view, St. Martin du Méjean, Arles, 1989.
Gelatin-silver prints under glass and colored pencil on wall. Collection the artist.

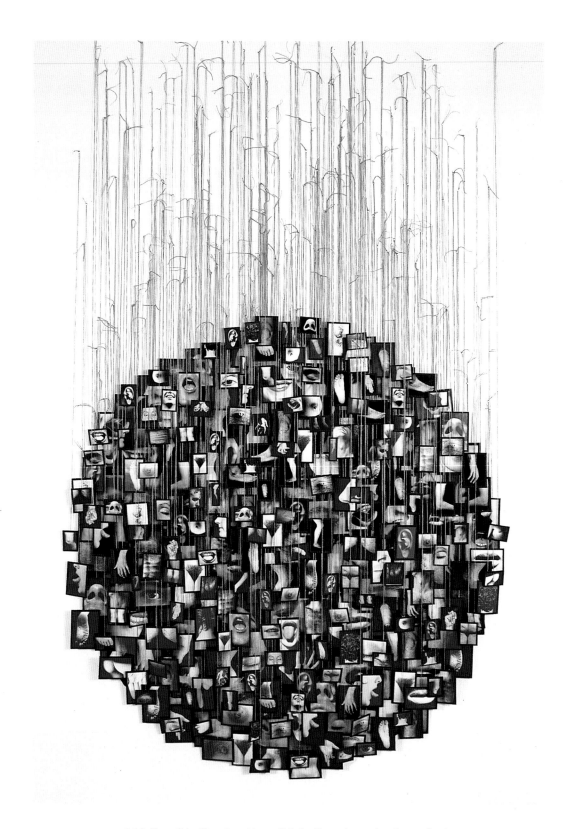

16. My Vows (Mes Voeux). *1988–91. Gelatin-silver prints under glass, and string.*
The Museum of Modern Art, New York. Gift of The Norton Family Foundation.

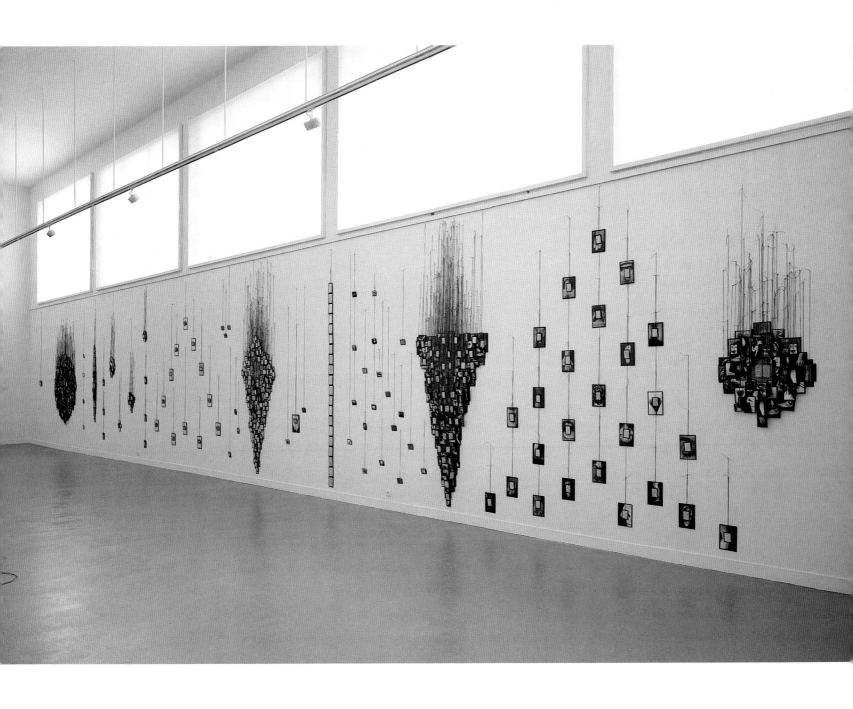

17. My Vows (Mes Voeux). *1988–89. Installation view, Musée d'Art Moderne de la Ville de Paris, 1989.*
Various mediums on gelatin-silver prints under glass, and string.

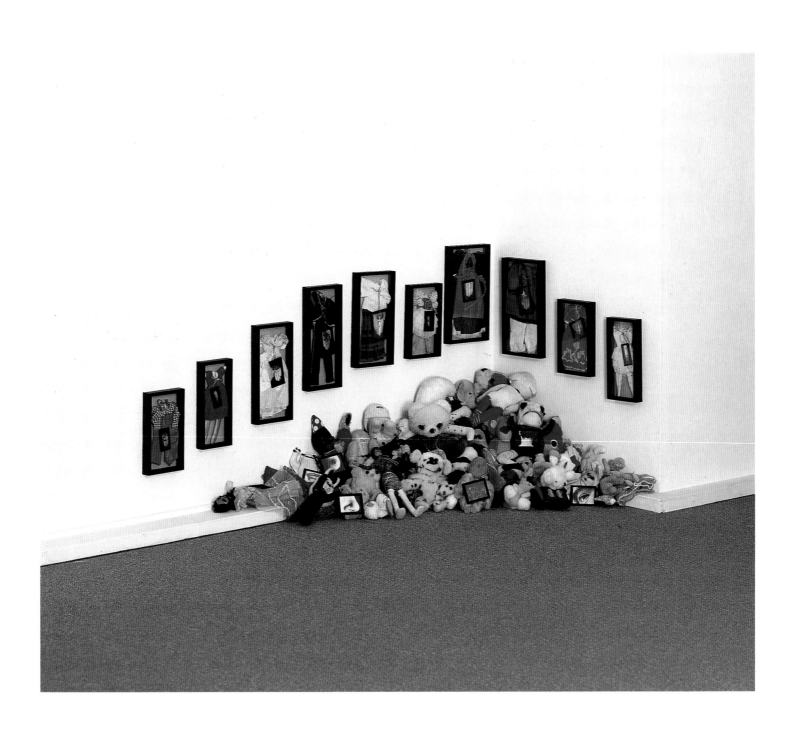

18. The Story of Little Effigies (Histoire des petites effigies). *1990. Plush toys and ten framed collages, each with doll clothing and charcoal on gelatin-silver print under glass. The Norton Family Foundation.*

to the animal they accompany. The words written repeatedly on the wall below come from the list of useful words prepared by Messager. They seem to address another reality, perhaps a time when the toy was loved by a child, or another entity entirely, such as a long-lost friend or lover. Messager requires the viewer to shift in small movements from element to element, creating a vaguely uncomfortable sense of displacement, an awareness of substitution. In the forced intersection of words, images, and objects, the logic of usual conditions must be abandoned. A single, specific meaning is difficult to synthesize from these elements; multiple potential meanings emerge that would not be apparent under normal circumstances. Messager has talked about the significance for her of this indeterminacy: "Meanings can migrate; those that have no certain value are the most dangerous." In these works a change in name or context allows ordinary objects to take on extraordinary functions or significance; in this unsettled state of affairs, the unvalued can become powerful.

In her series *The Story of Dresses* (*Histoires des Robes*) (1988–92; figs. 21 and 22), Messager again focused on objects rather than the people to whom they belong and used dresses as a substitute for the female body; the body has "evaporated."[27] Hermetically sealed in boxes, behind glass like sacred relics, the dresses are accompanied by memories and associations manifest in drawings and photographs attached to them with pins and bits of string. Each replaces a body and alludes to its now-stilled movements. These works are emphatically mortuary, and, as do photographs, each prolongs a presence: a child with its fairy tales, a woman whose desire for physical movement is represented by photographed body parts, a mother with age inscribed in the lines on her

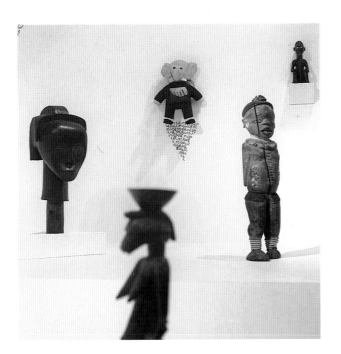

ABOVE: *19. Detail of* My Little Effigies (Mes Petites Effigies). *1988. Plush toy, gelatin-silver print under glass, and colored pencil on wall. Collection Stephen Johnson and Walter Sudol.*

LEFT: *20.* My Little Effigies (Mes Petites Effigies). *1988. Installation view with African sculpture, Musée d'Art Moderne de la Ville de Paris, 1989. Plush toy, gelatin-silver print under glass, and colored pencil on wall. Musée d'Art Moderne de la Ville de Paris.*

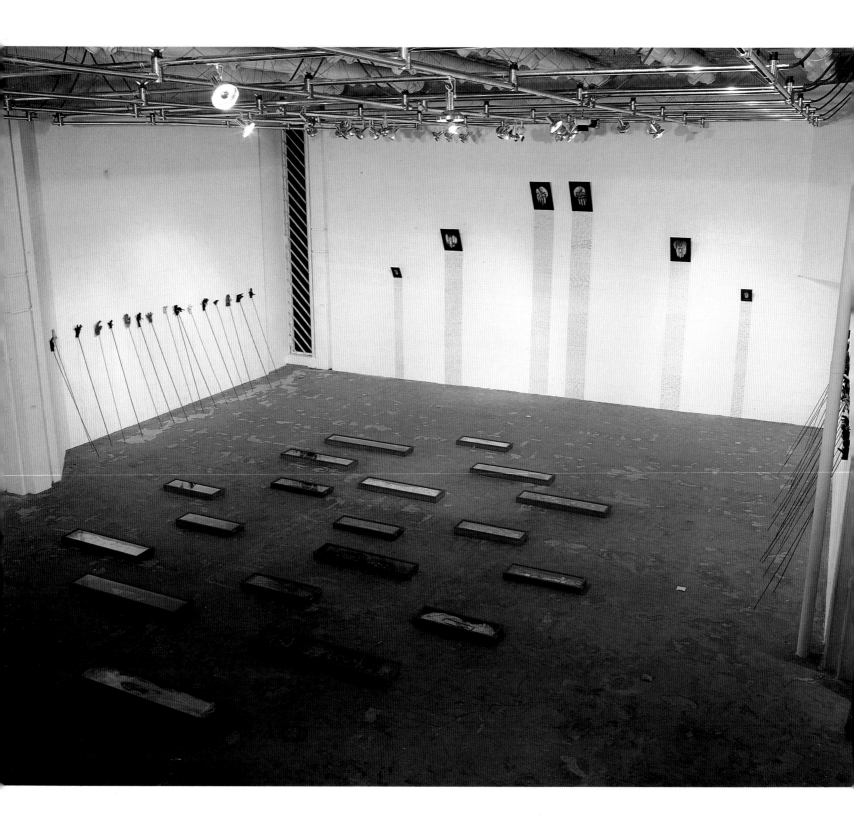

21. The Story of Dresses (Histoire des robes). *1990–91. Floor installation, with* Untitled *(left and right walls) and* Lines of the Hand *(rear wall),*
The Douglas Hyde Gallery, Trinity College, Dublin, 1992. Dresses and mixed mediums in glass and wood boxes. Collection the artist.

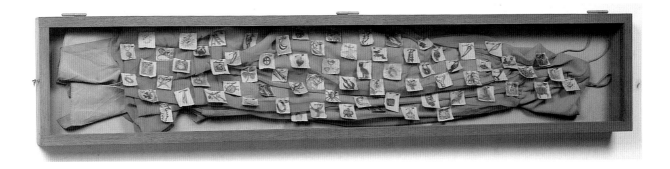

22. The Story of Dresses (Histoire des robes). *1990. Dress, crayon on paper, string, and safety pins in glass and wood box. Collection the artist.*

hands and breasts. This array of coffins conjures a family or community of women; Messager commemorates her mother in one piece in this series, but the others represent archetypal and idealized aspects of herself, past and present, reiterating the multiple identities she established for herself at the beginning of her work.

From 1991 to 1993 Messager created a monumental series titled *The Pikes (Les Piques)* (figs. 23 and 24, and see figs. 2 and 58). In one work, more than two hundred tall rods or pikes impale or support objects and lean in a jungle of verticals along adjacent walls. The implicit violence refers to the uprising of the *sans-culottes* and the Reign of Terror during the French Revolution, when long, sharpened poles or *piques* were used to impale the heads of the guillotine's victims. Messager's pikes present objects and images in a nightmarish density of tiny, limp figures, body parts, images of rape and military devastation, maps, and densely scribbled drawings. The objects are doll parts and stuffed fabric figures made by Messager herself in gruesome combinations of headless torsos, collections of too many arms and legs, and internal organs encased in nylon hosiery. The maps show various contemporary political entities in Africa, Europe, and the Mideast; the drawings depict open-mouthed corpses and homeless people; and the abstract, frantic scribbles express abject despair. Nothing is presented whole: the forms seem to be pieces of unfinished, interrupted stories scattered across the room, moving from social crimes to crimes of neglect to violence against women to war. Everything portrayed has been victimized, eviscerated, devastated beyond redemption.

Messager had come to a place in her work where she wanted to deal aggressively with the significant issues she saw in events unfolding around her, to confront the relationship of the individual to history and mass and global cultures. She has explained that she found

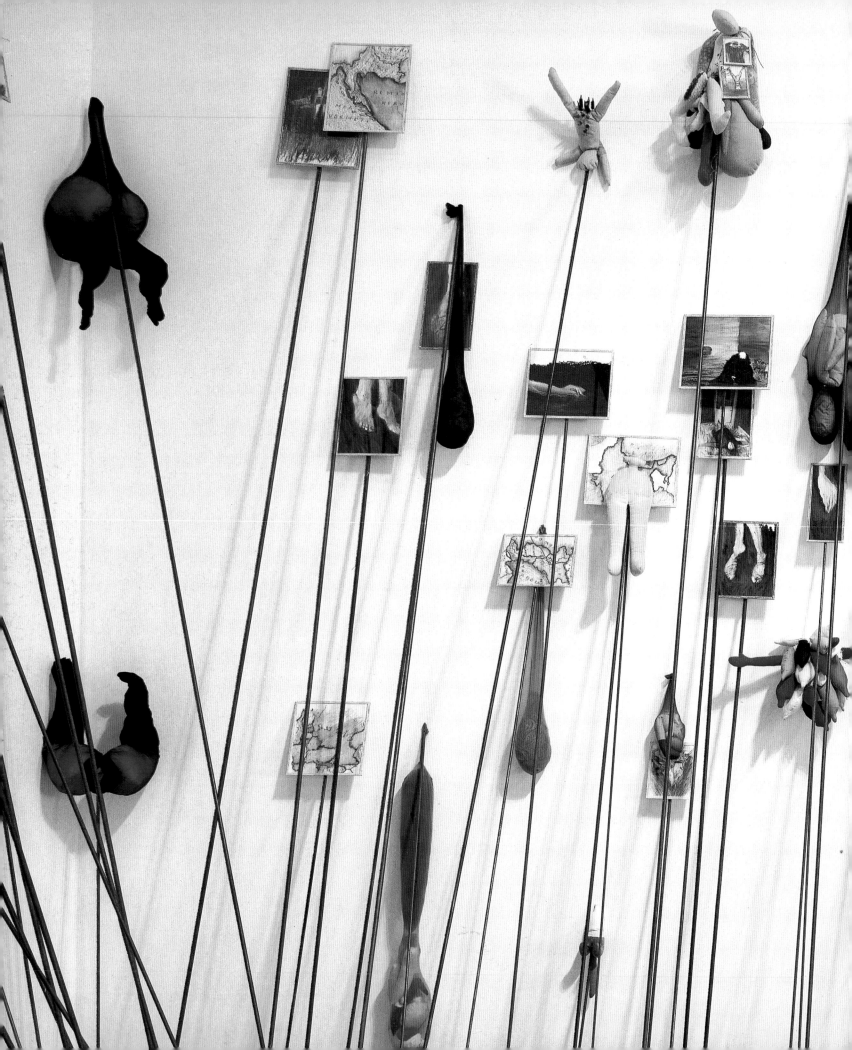

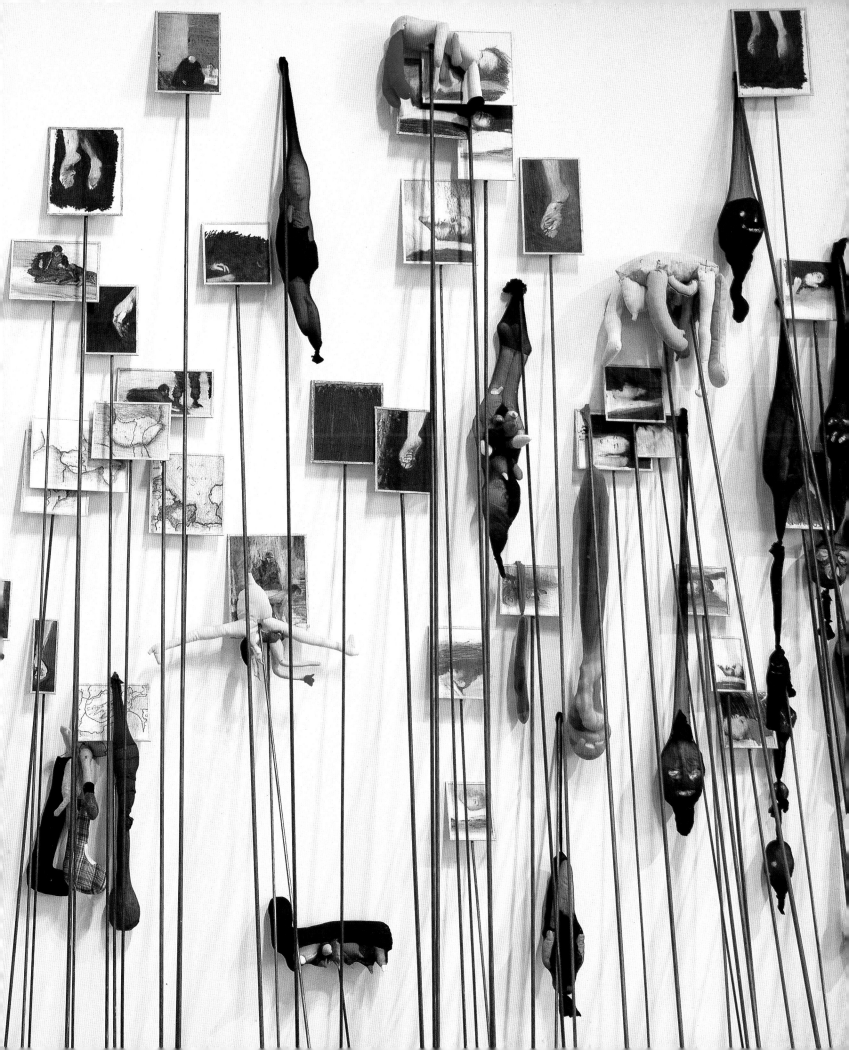

photographs in a magazine, one of a man with a sack over his head carrying some pikes, and was inspired to manifest this and other images of recent events in her sewn objects. She deliberately mixed life-size, sewn fragments of bodies and smaller, traumatized dolls and fetishes with representations of geographical and political spaces and renderings of vivid psychotic hallucinations. Anonymous individuals and important events and entities all exist in the same space, crowding each other yet immobilized, their different discourses adding another jarring effect to the overwhelming disorientation. *The Pikes* seem to signal an overt threat to civilization, sounding an alarm recalling the warnings of Theodor Adorno and other modern philosophers against the debasing influences of mass culture.[28] However, in contrast to their elitism, Messager sympathizes with the downtrodden, who have been impaled by a global corporate culture, which renders their individual stories and lives insignificant. By appropriating the pike as a revolutionary sign, she rebels against the powers that perpetuate the struggle of dispossessed people. This combination of the fantastic and the ordinary, the imagined and the hideously real, creates a revolutionary carnival that rejects hierarchies of taste, behavior, and decorum. It overloads the viewer's senses and escapes categorization; in its jumbled outpouring of different mediums and powerful emotions, it liberates meanings not normally manifest.[29]

In another disturbing display of sympathy and sadism, Messager moved her art completely away from the wall and constructed tableaux in which taxidermized animals congregate uneasily in groups. In *Nameless Ones (Anonymes)* (1993; see fig. 1), the animals are impaled on freestanding pikes. The gestures of some are almost jaunty, yet the strange combinations of rodents and birds and their remove from their normal context are disquieting. A number of the animals are hooded, bringing to mind images of hostages, condemned figures, and executioners. In *Untitled (Sans titre)* (1993–95; fig. 25) the ambivalence continues: the animals have returned to the floor, but the mystery of their unexplained assembly is deepened by Messager's combining of different species that would appear to be natural enemies; she even forces them together in one figure—for example, putting the head of a fox on a hen. Each of the groups is obscured within a shroud of mosquito netting, and in some of the installations the taxidermized animals are joined by stuffed animals Messager has found. There is menace in the pose of these strange creatures as well as sadness in their seeking each other's company as if they were survivors of a disaster. They

PREVIOUS PAGE: 23. The Pikes (Les Piques). *1991–93. Installation view, Musée National d'Art Moderne, Centre Georges Pompidou, Paris, 1993. Parts of dolls, fabric, nylons, colored pencils, colored pencil on paper under glass, and metal poles. Musée National d'Art Moderne, Centre Georges Pompidou, Paris; and collections Michael Harris Spector and Dr. Joan Spector, and the artist.*

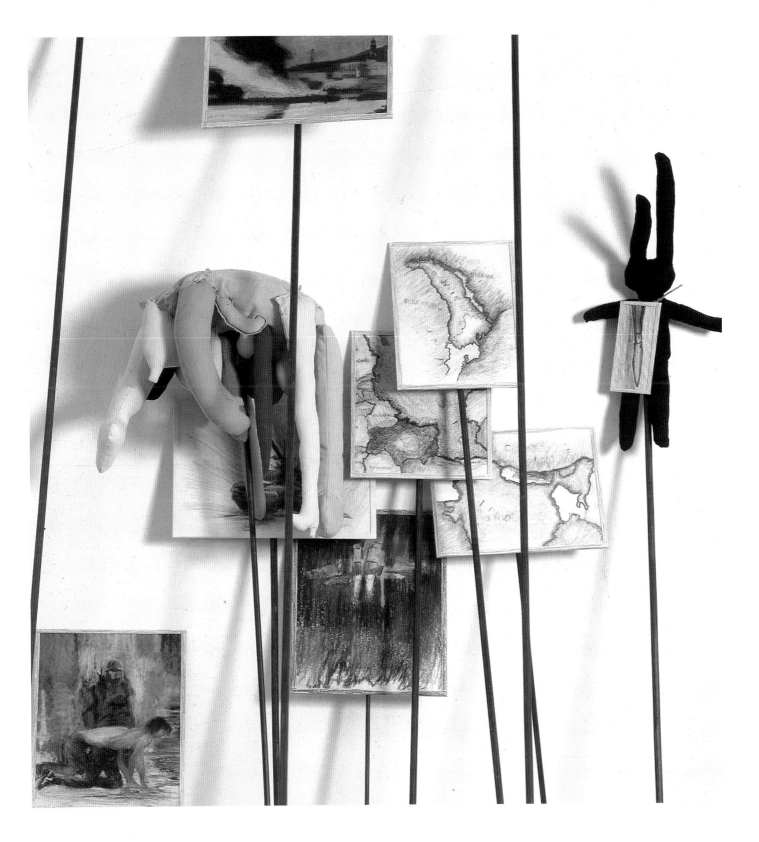

24. *Detail of* The Pikes *(fig. 23).*

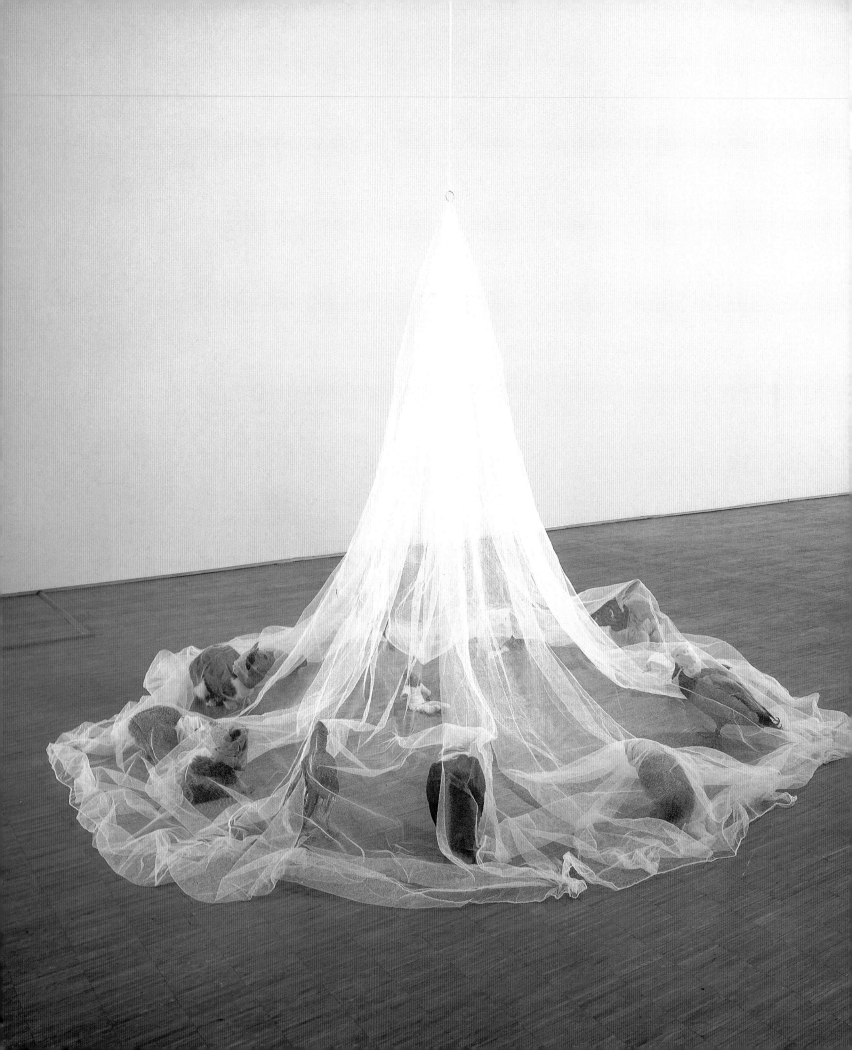

represent a chaotic anarchy in which individuals are not single entities but are composed of parts that come together without regard to the hierarchy of species; they create a separate space in which anything—good or evil—may take place.

A completely different space is evoked in the installation work *Penetration (Pénétration)* (1993–94; fig. 26). Messager sewed shapes from brightly colored fabric and stuffed them to resemble human internal organs. Hanging on slight, soft-colored angora yarns in a dense grouping, the forms create a floating forest of anatomical parts. Far from gruesome, the piece resembles a three-dimensional anatomical model, with its separate elements and colors taken not from reality but from medical illustration. In fact, much like *My Works*, *Penetration* is diagrammatic and maintains a conceptual distance from its ostensible subject. It provides a compelling visual feast that does not connect with the reality of the body's internal functions: gaily colored organs hang in clusters and shapes repeat randomly, much as do the isolated body parts in Messager's dense *My Vows*. The work remains distinctly visual and cerebral: a conceptualization of the body rather than the body itself, a view of ourselves that we know not from direct observation but from analogues, representations devised from scientific research and consensus. The bright, soft shapes are not repellent or frightening but oddly appealing, like stuffed animals or dolls. In this swarm of gently moving human organs we can conceive of our own interiority.

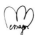

When asked her purpose in making art, Messager quotes the artist Robert Filliou: "Art should make life more interesting than art," which recalls not only her playfulness with language, but also mirrors the strategy of art doubling back on and commingling with life. While the facts of her life are apparently present in her art, much of Messager's artistic persona is invented: autobiographical in appearance but not in fact. Messager is interested in the imposed dichotomies of art and life, fact and fiction, individual and society, and in obfuscating and conflating them. She similarly subverts trust in the benign presence of everyday objects, and she dislocates the meaning of language, deforming it through word play or repetition that robs words of their ordinary significances. She refers to her work as *faire bonne figure* ("putting up a good front") as well as *faire des histoires* ("making trouble"). She has been quoted: "I think, besides, that one shouldn't say too much, show too

25. Untitled (Sans titre). *1993. Installation view, Musée National d'Art Moderne, Centre Georges Pompidou, Paris, 1993. Mosquito netting, taxidermized animals, fabric, and string. Collection the artist.*

much, reveal too much . . . just a few traces, a bit derisory. . . . Art is more on the side of conspiracy and conjuration."[30]

Like a number of contemporary artists who are interested in the various kinds of spaces between our constructions of self and society, Messager works both from within tradition and as an outsider. She deliberately shifts her own position stylistically and conceptually to carry that of the viewer to a new perspective. Like Joseph Beuys, she is the teller of her own tale; like Cindy Sherman, she is an actor in a drama not her own. Like Louise Bourgeois, she has taken important ideas about physical experience from the Surrealist tradition. Like Bruce Nauman, she has constructed a sort of spectacle by crossing the boundaries of good taste. Messager has fashioned a persona that allows her all of the roles she desires: the persona is chimerical and shares many methods and ideas with the artists of her generation, but also does not.

Messager's constructions parallel the philosophical writings of French feminist writers such as Hélène Cixous and Luce Irigaray. As did Messager, they emerged in the late 1960s and early 1970s, and they are not interested in providing an oppositional and separate polemicism of the type articulated by earlier French feminists including Simone de Beauvoir. Their strategies focus on the invention of an open and multiplicitous definition of individual identity. The similarity of these thinkers' concerns stems from a shared desire to change the exclusionary nature of social institutions and to include marginalized groups and forms. Their strategies are very much like Messager's: the merging of many sources; their articulation in a bricolage style, which undoes the authority of one form or mode; and the use of word games. For example, they may combine different expository styles in a single essay; use sources that traditionally have little scholarly weight, such as anecdotes or fairy tales; and turn language upon itself to loosen hidden meanings. The title of Irigaray's best known work is a playful double entendre: *Ce sexe qui n'en est pas un* (This sex which is not one).[31] Cixous has written extensively on the natural subversiveness of the state of being female and has incorporated stream-of-consciousness techniques into her essays, clouding the difference between expository and fictional writing, much as Messager has confused fact and fiction. In an important essay, "The Laugh of the Medusa," Cixous wrote: "If [woman] is a whole, it's a whole composed of parts that are wholes, not simple partial objects but a moving, limitlessly changing ensemble . . . an immense astral space not organized around any one sun that's any more of a star than the others."[32]

Messager's feminism is just as complex if not admitted (there is a tradition of not wanting to be named "feminist" in France, where theoretical and philosophical positions have been

aggressively institutionalized).[33] As with many of her feminist contemporaries, it is not the feminine characteristics of her work that Messager has emphasized, but the transgressive aspects of her process and the resulting dislocation and transformation. In her art things become other things: they are allowed an alternate existence in which definitions—and the prevailing cultural values that provide the definitions—can be challenged. Messager does not invent new forms but moves away from stereotypes and archetypes by conjuring up a mélange. Her meanings are located in the dialectic, in the positions between things; she reevaluates traditional cultural constructs and exposes both their arbitrariness and their reversibility.

Messager not only crosses the boundaries of sexual indentity with impunity, she challenges the hierarchy of prevailing cultural values by drawing her imagery and her conceptual base from a wide-ranging field, without regard to art or life, high or popular forms:

> It's true that we could call the combination of painting and photography a bad
> marriage! I like bric-a-brac, tinkering around, making different genres collide.
> . . . I like being able to refer to Edward Lear and James Ensor without estab-
> lishing a hierarchy, putting on the same plane William Blake and Walt Disney,
> comedy and tragedy, the sublime and the tacky.[34]

She claims pornographic imagery as her own fantasy, endows scissors with sex, transforms palmistry images into religious ex-votos, makes fellow thespians of animals that are mortal enemies. In her world, not only is rationality suspended to permit these combinations, she offers a carnivalesque display of her violation of natural and human laws. The sense of carnival is present not only in the colorful, distorted forms but also in the artistic intent, which consumes differences between good and bad art. This idea of the carnival evaluates positively forces that, historically suppressed by the bourgeoisie in their upwardly mobile withdrawal from popular forms, have reemerged in displaced and distorted form as objects of phobias and repressed desires.[35] The term *carnival* has recently been used to describe all forms that invert categories of hierarchy and value. The carnivalesque includes profane language—curses and colloquialisms that disrupt polite discourse—and performances and spectacles in which the genitalia are allowed to invade realms of proper conduct.[36] Furthermore, the carnivalesque celebrates the transgression of traditional definitions and the mixing of previously separate realms:

> One might say that carnival celebrates temporary liberation from the prevailing
> truth of established order; it marks the suspension of all hierarchical rank,
> privileges, norms, and prohibitions. Carnival was the true feast of time, the
> feast of becoming, change, and renewal. It was hostile to all that was immortal-
> ized and complete.[37]

The carnivalesque names the strong transgressive nature of Annette Messager's art. The variety of formal elements in her work echoes and reinforces her early abandonment of rational, hierarchical thinking. In spite of the enormous range of aesthetic presentation, certain debased or fear-provoking elements consistently reappear and a dark mood of challenge persists. The uncanny melding of different aspects of life—from the contradictory roles assigned to women to the unbelievable fusion of feathered and furred creatures—is a tenacious theme in each of her bodies of work, as if Messager intended somehow to encompass all possible permutations regardless of the logic to which they had previously conformed. She does so not by attempting to create a new or reformed hierarchy but by deliberately and effectively subverting and disrupting knowledge based on established and accepted categories. Her works are fragments and conglomerations, dislocations and conjunctions—eruptions in the solitary psyche as well as in the social activity of crowds. She has forcefully illustrated the idea that all things, whether a child's beloved toy, an innocuous piece of embroidery, or a word with seemingly unambiguous meaning, can be transformed into potent expressions of their polar opposites. In her varied work, Messager creates an inescapable and compelling sense of dramatic exhilaration in an endless carnival of dread and desire.

26. Penetration (Pénétration). *1993–94. Installation view, artist's studio, Malakoff, France, 1994. Fifty sewn and stuffed fabric elements, and angora yarn. Collection the artist, courtesy Monika Sprüth Galerie, Cologne.*

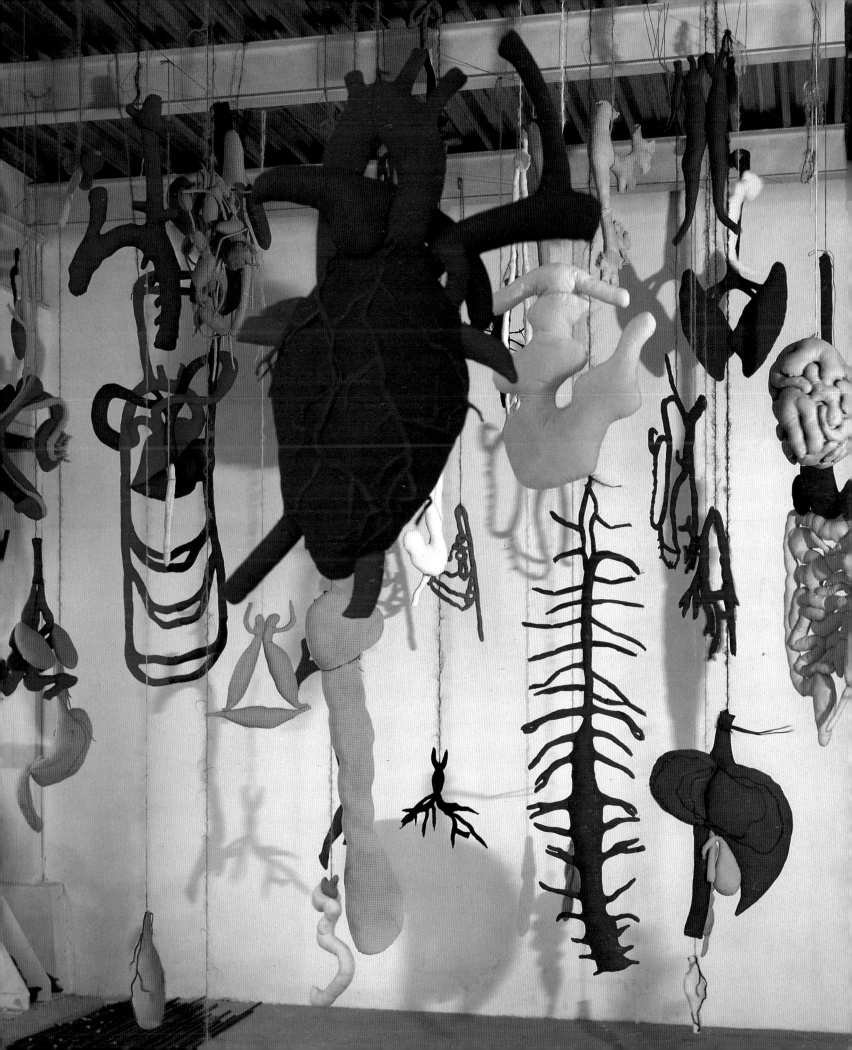

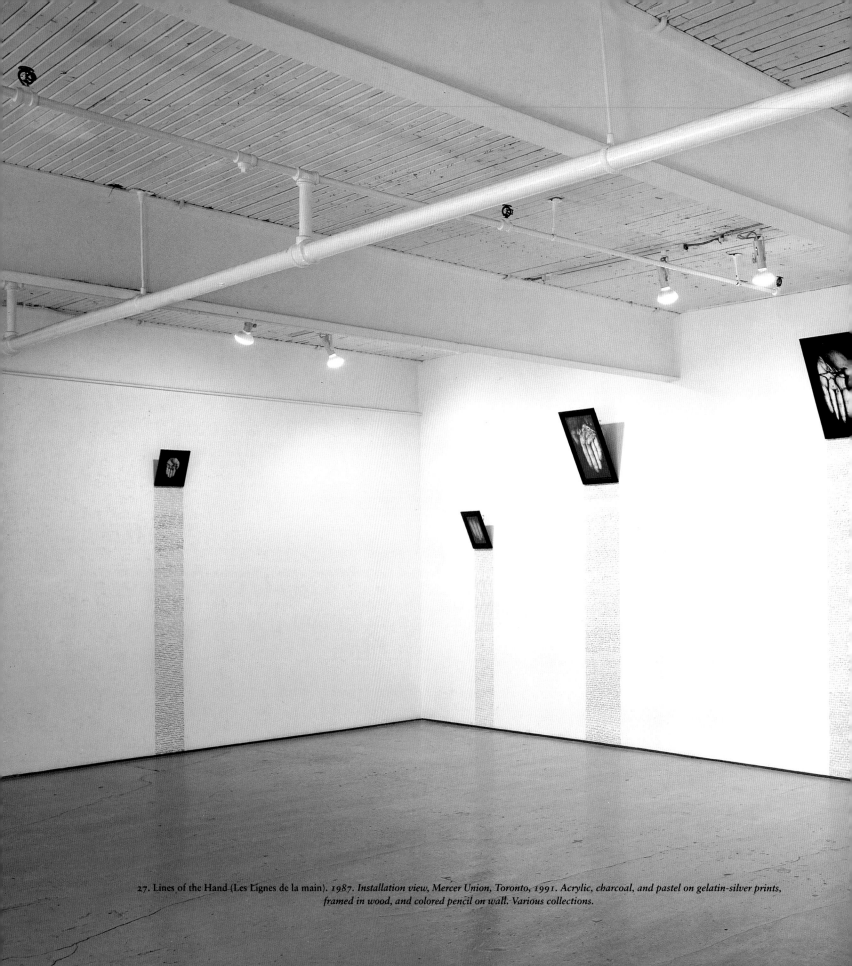

27. Lines of the Hand (Les Lignes de la main). *1987. Installation view, Mercer Union, Toronto, 1991. Acrylic, charcoal, and pastel on gelatin-silver prints, framed in wood, and colored pencil on wall. Various collections.*

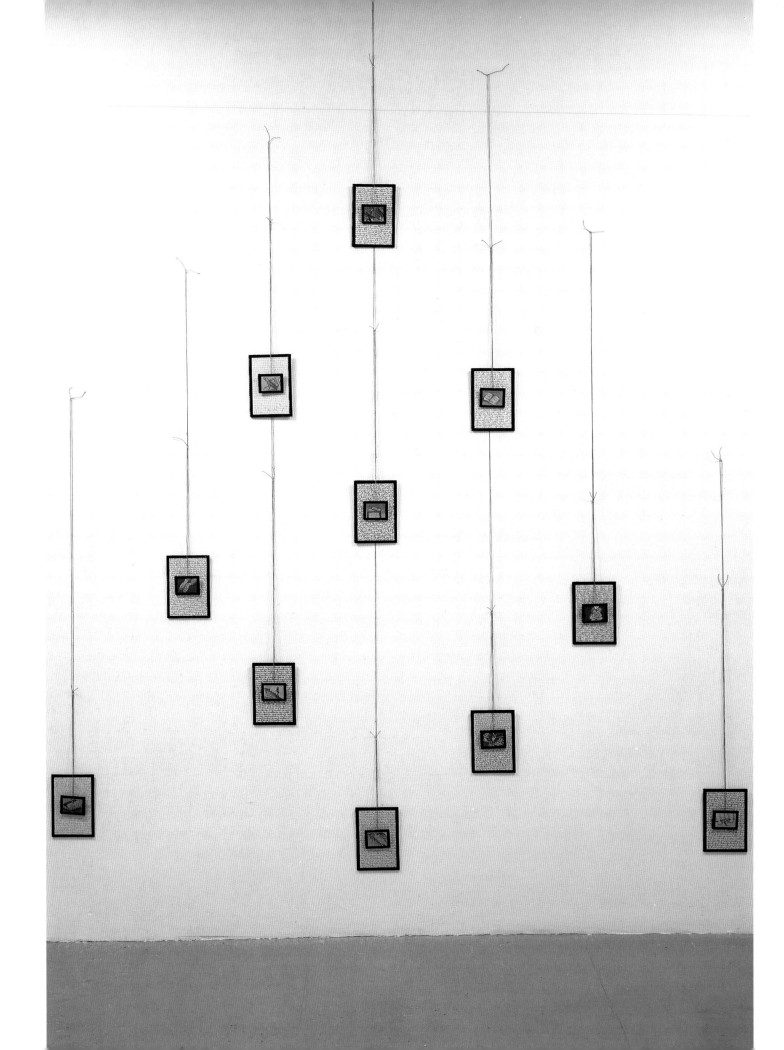

Notes

1. Interview with the artist, Paris, 18 March 1994. Unless differently cited, this interview is the source of all unattributed direct and indirect quotations of Annette Messager in this essay. I thank Anne Rochette for translating assistance during the interview.

2. Mikhail Bakhtin, *Rabelais and His World*, trans. Helene Iswolsky (Cambridge, Mass.: M.I.T. Press, 1968).

3. Bernard Marcadé, "Annette Messager," trans. Catherine Liu, *Bomb* 26 (Winter 1988/89): 32.

4. "The art of Annette Messager is deliberately an art of crossbreeding (*un art du métissage*). She moves from photography to painting and deliberately defaces their specialties . . . she has a horror of things in their place. When her activity is susceptible to systemization, to fossilization as a normal mode, she changes her position." Bernard Marcadé, "Les Accouplements monstreux d'Annette Messager," *Art Press*, no. 69 (April 1983): 18–19.

5. See *Une Scène parisienne 1968–1972* (Rennes: Centre d'Histoire et l'Art Contemporain, 1987) for a detailed chronology of the activities of this circle of artists, which also included Bernard Borgeaud, André Cadere, and Gina Pane.

6. At that time, Boltanski and Messager both created semiautobiographical works and occasionally collaborated. One of their first joint artworks was documentation of a fake honeymoon in Venice in 1975; some of the photographs by Boltanski and drawings by Messager from that project were shown in a 1976 exhibition at the Rheinisches Landesmuseum, Bonn, and published in an accompanying catalogue, *Modellbilder*.

7. Jean Claude Kerbouc'h, "My Pale Nights," in Marcel Jean, ed., *The Autobiography of Surrealism* (New York: Viking Press, 1980), 443. The essay originally appeared in the magazine *Combat*.

8. The Situationist International's view of society is best expressed in Guy Debord's *Society of the Spectacle* (Detroit: Black & Red, 1970; reprint, 1983). Debord was editor of the journal *Internationale situationniste* from 1958 to 1969. The book was first published in 1967 by Editions Buchet-Chastel, Paris.

9. Helen Lewis, *Dada Turns Red: The Politics of Surrealism* (New York: Paragon House Publishing, 1990), 171.

10. Marcadé, "Annette Messager," 32.

11. "Annette Messager, or the Taxidermy of Desire," interview by Bernard Marcadé, in *Annette Messager, comédie tragédie, 1971–1989* (Grenoble: Musée de Grenoble, 1989), 160–61.

12. The female body as a site of voyeuristic struggle is discussed by Laura Mulvey in "Visual Pleasure and Narrative Cinema," in Mulvey, ed., *Visual and Other Pleasures* (Bloomington: Indiana University Press, 1989), 14–26.

13. Jean-Michel Foray, "Annette Messager, collectionneuse d'histoires," *Art Press*, no. 147 (May 1990): 17.

14. For an outline history of feminism in France in the 1970s, see Elaine Marks and Isabelle de Courtivron, eds., *New French Feminisms* (New York: Schocken Books, 1980), 24–27.

15. Messager later published the proverbs in a limited-edition artist's book (in French with translations in Italian and English), *Ma Collection de proverbes, Annette Messager collectionneuse* (Milan: Giancarlo Politi Editori, 1976).

16. Messager has said: "I am opposed to the 'good taste' of French painting. . . . I especially like to absorb images, events. . . . I don't think artists should be blotting paper, but all the same, one takes in just as easily images in bad taste as ones called 'cultural.'" Marcadé, "Les Accouplements monstreux," 18.

17. "The grotesque is not only the Other but the boundary phenomenon of hybridization or inmixing, in which self and other become enmeshed in an inclusive, heterogeneous, dangerously unstable zone." Peter Stallybrass and Allon White, *The Politics and Poetics of Transgression* (Ithaca: Cornell University Press, 1986), 193.

18. In the interview with the author (see note 1), Messager talked about her respect for Hitchcock and his pioneering use of the close-up shot.

19. Bruno Bettelheim, *The Uses of Enchantment: The Meaning and Importance of Fairy Tales* (New York: Vintage Books, 1977), 7.

20. Françoise-Claire Prodhon, "Annette Messager," *Flash Art*, no. 142 (October 1988): 142.

21. Daniel Soutif, "Annette Messager, Le Consortium," *Artforum* 27, no. 2 (October 1988): 160–61.

22. Annelie Pohlen, "The Utopian Adventures of Annette Messager," *Artforum* 19, no. 1 (September 1990): 115.

23. The French psychoanalyst Jacques Lacan, using structuralist linguistics, reinterpreted Freudian psychology and its definitions of the self. For Lacan, what is human is precisely the absence of an identity and the need to construct it. See Stephen Melville "Psychoanalysis and the Place of Jouissance," *Critical Inquiry* 13, no. 2 (Winter 1987): 351.

24. John Rajchman, "Lacan and the Ethics of Modernity," *Representations*, no. 15 (Summer 1986): 45.

25. See Ralph Rugoff, "Mike Kelley/2 and the Power of the Pathetic," in Elizabeth Sussman, ed., *Catholic Tastes* (New York: Whitney Museum of American Art, 1993), 162 and 165, for a discussion of the sexual aspect of Kelley's use of stuffed toys.

26. *Histoires de musée* was held at the Musée d'Art Moderne de la Ville de Paris, 23 June to 15 October 1989. Eleven French artists, including Daniel Buren, Sophie Calle, and Bertrand Lavier interpreted the museum's functions and commingled their own works with those in the museum collection or, as in the case of Messager, ones lent to the museum.

27. Mo Gourmelon, "An Accomplished Schemer," in *Annette Messager: Telling Tales* (Bristol: Arnolfini and Manchester: Cornerhouse, 1992), 20.

28. Theodor Adorno, an influential figure in the Frankfurt School of philosophy, wrote extensively about the eroding effect of mass culture. See the chapter "The Culture Industry: The Enlightenment as Mass Deception," in his collaboration with Max Horkheimer, *Dialectics of Enlightenment* (New York: Continuum Press, 1990), 120–67. He and Horkheimer discuss "the regression of enlightenment to ideology which finds its typical expression in cinema and radio" (xvi).

29. See Stallybrass and White, *Politics and Poetics of Transgression*, 171–82, for a discussion of "carnival" and its use by Freud and Bakhtin as a metaphor for personal and social catharsis.

30. Messager quoted in Marcadé, "Annette Messager," 29.

31. Luce Irigaray, *Ce sexe qui n'en est pas un* (Paris: Minuit, 1977). Translated into English by Claudia Reeder in Marks and Courtivron, *New French Feminisms*, 99–106.

32. Hélène Cixous, "The Laugh of the Medusa," trans. Keith Cohen and Paula Cohen, *Signs* (Summer 1976): 889. The essay first appeared in the French periodical *L'Arc* in 1975.

33. Marks and Courtivron, *New French Feminisms* (1980), x–xi.

34. Marcadé, "Annette Messager," 30.

35. Stuart Hall, "Metaphors of Transformation," in Hall, ed., *Allon White, Carnival, Hysteria and Writing* (Oxford: Clarendon Press, 1993), 3.

36. See Stallybrass and White, introduction, *Politics and Poetics of Transgression*, 1–26.

37. Bakhtin, *Rabelais and His World*, 10.

28. **My Vows (Mes Voeux). 1988–91.** *Eleven pairs of framed colored pencil on paper drawings and texts under glass, and string. Collection Clyde and Karen Beswick, Los Angeles.*

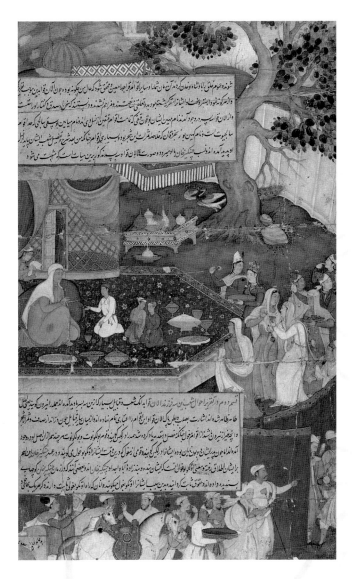

29. Alanquva and Her Three Sons, *page from* A Jami-Al Tawarikh
(History of the Mongols). India, Mughal, c.1596. Opaque watercolor on paper.
Los Angeles County Museum of Art, Nasli and Alice Heeramaneck Collection.
Museum Associates Purchase.

Line illustration reproduces figure in Jean-Martin Charcot, Leçons sur les maladies du système nerveux, faites à la Salpêtrière,
vol. 3 of Oeuvres complètes de J.-M. Charcot *(Paris: Aux Bureaux du Progrès Médical, 1885), 101.*

"Nourishment You Take"

Annette Messager, Influence, and the Subversion of Images

Carol S. Eliel

Influence—I think it's a sort of nourishment you take from other artists—it's
like the little sparrows, they are needy like that. When you're young, you take
in from a lot of sources; and afterwards, with all you've seen, you never know
where it all comes from, where you stop and it begins.

—Annette Messager

DANCER, NUN, PAINTER: Annette Messager the child wanted to be one of these when she
grew up. Body, spirit, illusion: these, in fact, are the subjects of the mature Annette
Messager's art. Very much of the late twentieth century yet continuing the romantic tradi-
tions of the eighteenth and nineteenth centuries, concerned with the ordinary and the every-
day yet fascinated by illusion and dream, highly attuned to contemporary culture yet deeply
influenced by art outside the cultural mainstream, Annette Messager has created a body of
work that is at once accessible and obscure, spiritual and worldly, personal and universal.
Both visually and conceptually, her work is rich and compelling. This essay will approach
Messager's work by examining the manifold roots of her imagery in both artistic and other
sources, influences that have come into play at various points and in different ways during
her ongoing career.

While all artists are influenced, consciously or not, by visual sources outside their own
work, for Messager such sources are not only inherent but essential to her art-making.
Everything from Goya to reports of the Gulf War, from Christian iconography to advertis-
ing imagery, feeds into her work. Like the sparrows taking their nourishment, Messager
absorbs and transforms imagery of every kind, at times in this process subverting the inten-
tions of those who made the images, to create her own work. The artist has likened the
diverse influences on and roots of her art to her concept of a woman's everyday existence:

In the life of a woman, you move from one thing to another; you cook in the kitchen, afterwards you have a tryst with a man, and after that you go to a museum. Life is like that, made up of diverse things. A day comprises—our thoughts comprise—completely diverse elements. When I refer to Goya, I should say that I may be just as influenced by graffiti I saw in the street or by bad advertisements for bras. All these provide one big source of nourishment for an artist, for me.[1]

The daughter of an architect who was also an amateur painter, Messager was born in 1943 in Berck, a seaside town in northern France known for a hospital where tubercular children are treated. Her father, who detested his profession and adored his avocation, encouraged Messager and her brother by giving them art supplies; in addition, he frequently took his family to visit churches in the area to see their stained-glass windows and altarpieces. "I was awed by the images of the church," Messager recalls. (Although her parents were lapsed Catholics, Messager was devoutly religious as a child.) Her father also often took her to the Musée des Beaux-Arts in Lille and other museums in northern France, Belgium, and the Netherlands. She particularly remembers looking at works by Francisco Goya and his followers, as well as by James Ensor, Chaim Soutine, and Francis Bacon.

When Messager decided to pursue studies in the visual arts, her parents, concerned about her financial security, encouraged her to pursue art education. She, however, wanted to study fine arts, and her parents finally acquiesced. Messager's gender stood her in good stead, since they felt that she would in any case get married and be supported by her husband; thus her career (or, conversely, her inability to find a job) would be irrelevant. In the early 1960s she chose to enroll in the Ecole des Arts Décoratifs (School of Decorative Arts), Paris, which she considered at the time to be a challenging, open, and liberal institution, rather than the Ecole des Beaux-Arts (School of Fine Arts), which she thought of as a moribund place "where one made nothing but paintings and plasters."

Around this time, her mother entered a photograph that Messager had made some years earlier in a worldwide contest sponsored by Kodak, and Messager won the grand prize, a round-the-world tour for two. Waiting until she was twenty-one because of the difficulty of international travel as a minor, Messager embarked with a family friend on a two-and-a-half-month journey to Hong Kong, Japan, the Philippines, Cambodia, India, and Israel. One of Messager's first acts on her journey was to buy a camera in Hong Kong—the first high-quality one she ever owned. Messager took many photographs on her travels and was struck by the great mix of cultures that she saw. She was particularly fascinated by Indian

sculpture and miniatures; the combination of album-sized images and text in the latter (fig. 29) would become a feature of her own work.

Over the next few years Messager also traveled to the United States (she won this trip while a student at the Ecole des Arts Décoratifs) and to Nepal and Ceylon. Her interest in her studies waned—"I spent my days looking at exhibitions around town and going to the movies"— and the director of the Arts Décos, as the school was known, asked her to leave. During this period Messager made what she has called Surrealist objects: reliquary-like wooden boxes with lids and drawers.[2] These works were influenced by Louise Nevelson, who at the time was Messager's only role model as a woman artist.

The student rebellion of May 1968 in France was a watershed for Messager, who recalls the importance at the time of the dictum that art is in the streets, not in museums. "Grand paintings, all the pictures of the Louvre—we were ready to burn them. All that was zip. . . . I wanted to work on the everyday, the ordinary, things from the street, from magazines. That was my '68." Although a women's movement began to take hold in France at the time, Messager shied away from a radical feminist stance, feeling that to be a feminist she would have to deny her femininity, something she was not willing to do. Yet Messager began to feel that, for her, being a woman and being an artist were inextricably linked. As she later explained,

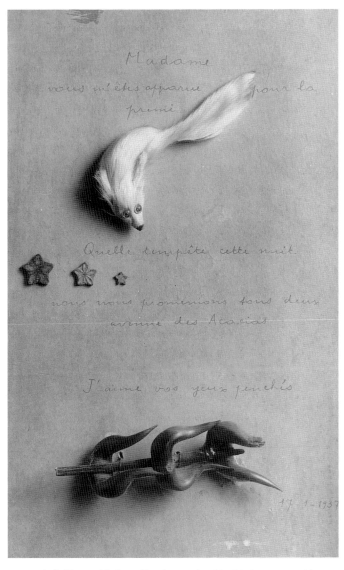

30. *André Breton.* Madame, You Appeared to Me (Madame, vous m'êtes apparue). *1937. Object-poem: mixed-medium assemblage and ink on paper, mounted on cardboard. Collection Timothy Baum, New York.*

If I didn't know what I wanted to do, I knew what I didn't want to do. In exhibitions, I saw strong and powerful painting, grandiose pictures, and I said to myself that perhaps there was something else. At the same time, I realized that the history of art was linked to a male history. . . . I was a woman who tried

Given that women have traditionally been devalued by a male-oriented society, Messager decided to exploit that very devaluation. Messager had been told that her work was good "'because it could have been done by a man.' I was scandalized by this language, by the unacceptable reference. . . . [Therefore] when I started working . . . I willingly took on . . . everything that was considered 'women's things,' and I tried to validate them."[4]

"If there are artists whom I feel close to," Messager has said, "they are the Surrealists."[5] They have long fascinated her, particularly for their stance on the intimate relationship

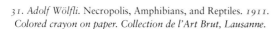

31. Adolf Wölfli. Necropolis, Amphibians, and Reptiles. *1911.*
Colored crayon on paper. Collection de l'Art Brut, Lausanne.

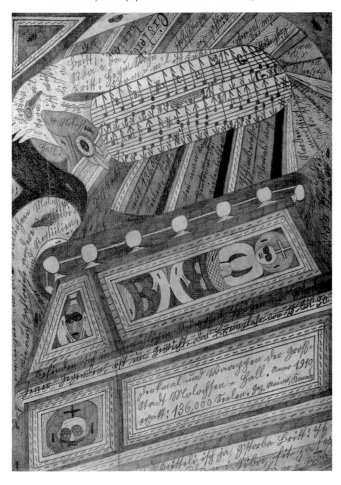

between the creative act and the artist's own existence; they were also interested in many aspects of what was then culturally devalued art: "primitive" artifacts, the art of the insane, objects by self-taught artists, etc.[6] "The Surrealists spoke of small [ethnographic] objects by Eskimos and others," Messager has stated. "André Breton was in fact a collector of all that. Thus the love which I have for these small objects without a doubt comes from Breton." Aspects of his "object-poems" even appear to anticipate Messager's early work (fig. 30). Ironically, the Surrealists are also among the most misogynous of artists, perceiving women as objects of desire to be treated as fetishes in service of the creative male. For Messager, the Surrealists were thus models to be exalted and subverted, artists who had an enormous influence, both positive and negative, in shaping her work.

Jean Dubuffet was also extremely important to Messager. Her father was a great admirer of Dubuffet's art, and Messager came to know not only his artistic creations but also his

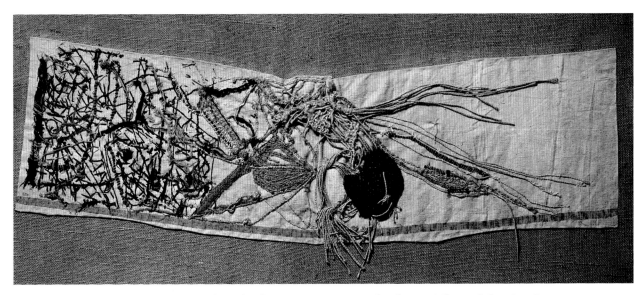

32. *Jeanne Tripier.* Large Rectangular Embroidery. *1935–39. Cotton, wool, and string. Collection de l'Art Brut, Lausanne.*

writings about culture, including *art brut* (raw art), his term for the art of the insane, the self-taught, and others outside the artistic mainstream. In 1967 a large exhibition of Dubuffet's personal collection of this work (now the core of the Collection de l'Art Brut in Lausanne) was held at the Musée des Arts Décoratifs in Paris. For Messager this show was an epiphany; she was "passionate, but really passionate" about the work in the exhibition, to the point that she stole from the museum bookstore Dubuffet's publications on *art brut*. The horror vacui of Adolf Wölfli's fantastic creations (fig. 31) and the compulsive richness of embroidered works by Jeanne Tripier (fig. 32) and others affirmed Messager's artistic tendencies.

In 1971 the Galerie Germain in Paris asked Messager to participate in an exhibition with wool as a theme, sponsored by the trade association Woolmark. "I remember very well, I was walking in a Paris street," Messager recalls, "and I stepped on a dead sparrow. I picked up this sparrow and returned home and knit a wool wrap for it." Thus began the series *The Boarders* (*Les Pensionnaires*) (1971–72; see fig. 3), her first work with taxidermized animals. Her concern with the sparrows reflected traditionally female maternal and protective instincts. Not only did she lovingly clothe the small creatures (whom she called her "boarders," as if her studio were "a sort of family boarding house with fake children"), she also baptized them and created sculptural devices to take them for "walks" and "punish" them.[7] She even created a feather alphabet to help them learn their letters. It is interesting that Messager referred to these birds as fetishes, recalling the Surrealists' relationship to their creations and suggesting the morbid and sadistic overtones of much Surrealist art (see fig. 30).[8]

Messager has repeatedly stated that taxidermy and photography "are the same thing: taxidermy takes an animal and freezes it, dead yet alive, forever. Photography also freezes—a sixtieth of a second—forever."[9] Likewise, photography and taxidermy both present images or objects that are simultaneously perceived as illusory and real (photography is traditionally considered the art form that completely and accurately depicts—even reflects—reality). Messager also feels that photographs, like taxidermized animals, have a compelling fetishism about them; thus her shift from *The Boarders* to her increasingly photo-based works of the 1970s and 1980s was logical and smooth.

The earliest works incorporating photographic elements are the album-collections made from about 1971 to 1974, comprising small, handmade notebooks or albums filled with a profusion of photographs, drawings, and writings on a variety of ordinary, often practical subjects; each album is accompanied by a collection of loose photographs, drawings, or other small, two-dimensional images. In many instances, the drawings in the album-collections are copied from photographs clipped out of sources such as newspapers and popular magazines; going a step further, Messager at times also included photographs of her own drawings. This conflation and confusion of the photographed and the drawn, the "real" and the "once removed" (or repeatedly removed) reflects Messager's fascination with mystery, illusion, and the "faux."

Messager has said that all of her work "is about imitation, about the faux," and she has spoken of a favorite literary passage, from Paul Morand's *Tendres Stocks* (*Green Shoots*), which perfectly reflects this interest:

> Stranger still is her taste for the faux. More than the object itself, she loves its imitation. She revels in her own deception and that of others. To see the looks which women give her pearls—she is amused to provoke such base sentiments at so little cost. She loves this paraphrase of the true, the modern religion of trompe-l'oeil and illusion, this latent mockery the faux presents. . . . To be in disguise is one of her joys. She paints her fabrics, dyes her carpets, bleaches her hair, tints her cats. She is surrounded by a thousand objects destined for other than their apparent uses, books which open into boxes, telescopic pen holders, chairs which become tables, tables which are transformed into screens.[10]

Messager in fact often exploits her conflation of the real and the faux to subvert the intentions of her original sources. Thus, for example, the tiny wool garments she knit for the

33. How My Friends Would Do My Portrait (Comment mes amis me feraient mon portrait), Album-collection No. 23. 1972.
Sixty-two ink on paper drawings and fifty-five gelatin-silver prints (album not pictured).
Courtesy Galerie Chantal Crousel, Paris.

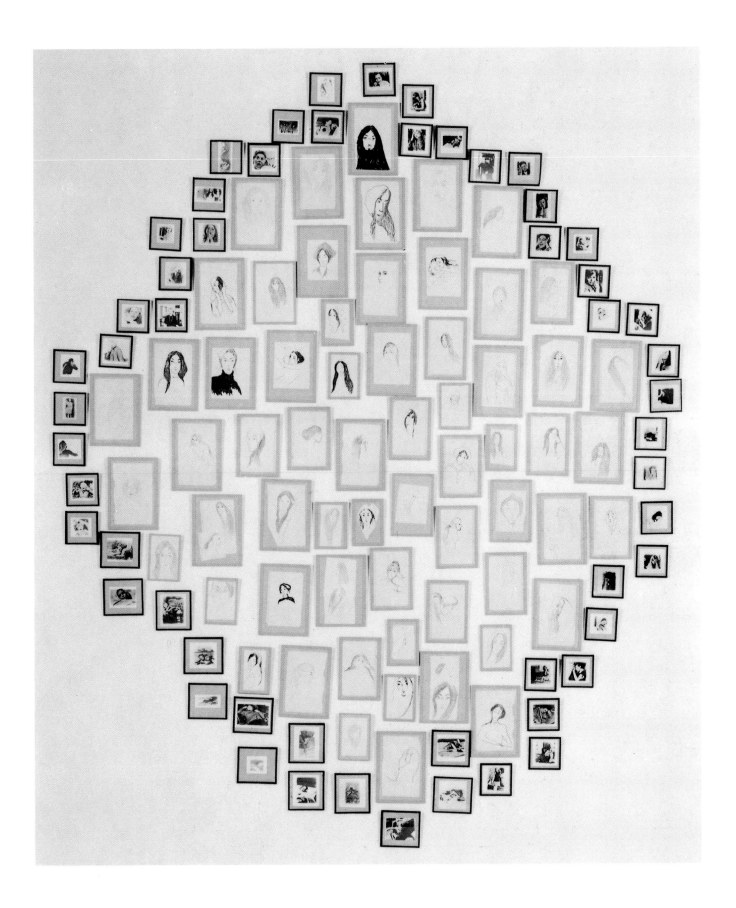

sparrows not only suggest their defenselessness, like that of infants, but also comment ironically on advertising imagery and marketing techniques, thereby subverting Woolmark's intentions in sponsoring an art exhibition.

In the early to mid-1970s, Messager lived in a small apartment; she worked at specific tasks and fabricated identities for herself in each of the apartment's two rooms (see front and back endpapers). In the room designated as the studio, where *The Boarders* was created, she called herself "Annette Messager Artiste." In the bedroom she was "Annette Messager Collectionneuse." There, she wrote in 1973, "I seek to possess and appropriate for myself life and its events; I constantly inspect, collect, order, sort, and reduce everything to numerous album-collections."[11] As we have seen, her experience of the 1968 student rebellion had led Messager to investigate in her art ordinary aspects of daily life, particularly that of women, and to work with images of popular culture culled from newspapers and magazines, particularly the fashion and family-oriented magazines that women traditionally read.

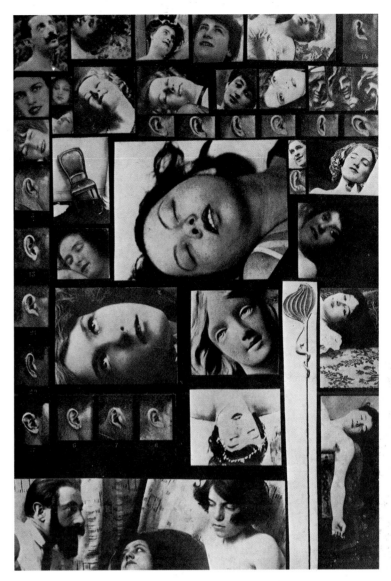

35. *Salvador Dali.* The Phenomenon of Ecstasy. *1933. Photocollage published in* Minotaure, *no. 3–4 (14 December 1933), p. 77.*

In album-collections such as *How My Friends Would Do My Portrait* (*Comment mes amis me feraient mon portrait*) (1972; fig. 33) and *Collection to Find My Best Signature* (*Collection pour trouver ma meilleure signature*) (1972; fig. 34), Messager attempted to define her own identity or identities. Works such as *My Needlework* (*Mes Travaux*

34. *Detail of* Collection to Find My Best Signature (Collection pour trouver ma meilleure signature), *Album-collection No. 24. 1972. Ink on paper. Collection the artist.*

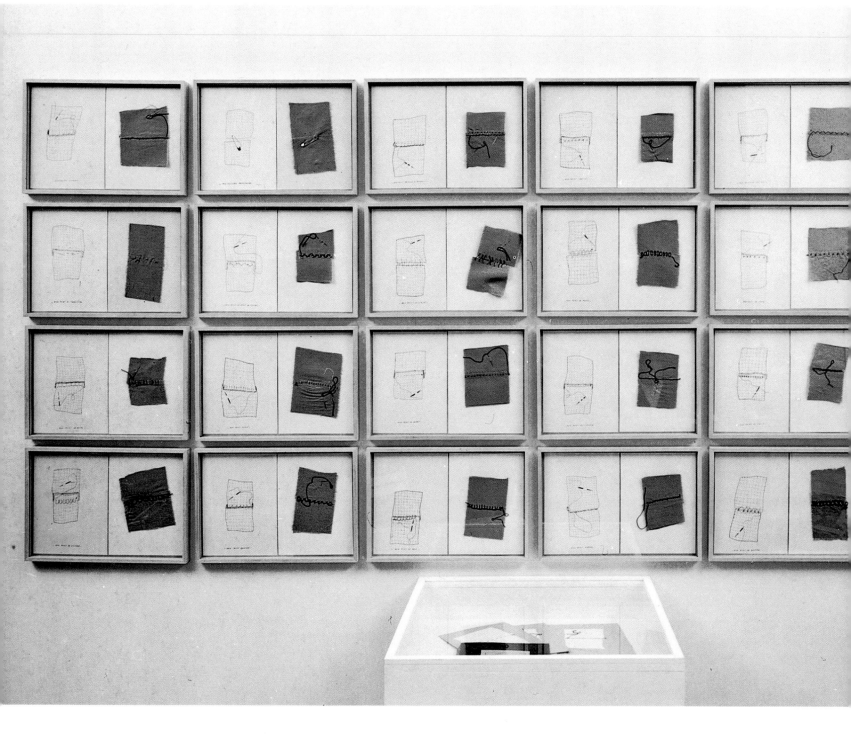

36. My Needlework (Mes Travaux d'aiguilles), Album-collection No. 7. 1972.
Twenty-four fabric, thread, and ink on paper elements, and one album. Musée de Grenoble, France.

d'aiguilles) (1972; fig. 36) and *Voluntary Tortures* (*Les Tortures volontaires*) (1972; see fig. 9) reflect her fascination with "women's work" and women's obsessions with their looks and bodies. *Voluntary Tortures* slyly undermines the voyeuristic implications of Salvador Dalí's *The Phenomenon of Ecstasy* (fig. 35), originally published in *Minotaure* in 1933. Dalí's photocollage includes images of ears from a nineteenth-century treatise on criminology, a sinuous fragment of an Art Nouveau sculpture, and the faces of women enjoying orgasm, excerpted from Victorian pornographic photographs.[12] Messager subverts Dalí's notion of heterosexual voyeurism and ecstasy with her own image, formally similar to Dalí's, of women voluntarily submitting to various torturous treatments and rituals intended to make them more attractive to men. *My Collection of Proverbs* (*Ma Collection de proverbes*) (1974; see fig. 8), in its medium of hand embroidery and through its "texts," addresses clichés concerning women and their roles ("Don't rely on a woman, even if she is dead"; "Where there is a woman, there is no silence"; "For a woman, wisdom teeth grow only after death"). The ambiguities, the simultaneously serious and tongue-in-cheek attitudes, the multiplicity of possible interpretations in these works are rampant and willful on the artist's part. Messager's interest in art outside the Western cultural mainstream informs these album-format combinations of small-scale images and texts as well as her use of embroidery as an art medium (see figs. 29 and 32).

Many other influences, both historical and contemporary, fed into the album-collections as well. Messager has said that she "adores" the small books by the arch-romantic William Blake, with their finely drawn, fantastic images, often combined with spidery, handwritten poetic texts. Messager's imagination was stimulated by Ed Ruscha's *Every Building on the Sunset Strip* (1966; fig. 37), which presents in a booklike format photographs of ordinary aspects of daily life. Ruscha's fascination, even obsession, with the quotidian affirmed Messager's inclinations, as did his use of the camera to fragment reality and of the book form to reassemble it. Similarly noteworthy for Messager was the conceptual work of Bernd and Hilla Becher, who present groupings of structures they photograph that are similar, such as water towers, cooling towers, and storage silos. In the late 1960s and 1970s Messager was also interested in the work of artists

37. *Ed Ruscha.* Detail of Every Building on the Sunset Strip. *1966. Artist's book with gelatin-silver prints in fan-fold format. Los Angeles County Museum of Art, Mr. and Mrs. Allan C. Balch Art Research Library.*

associated with Fluxus, including its French adherents Ben Vautier and Robert Filliou. Simultaneously conceptual and rooted in the everyday, the Fluxus movement—for which publications of every kind, including innovative books, were a favored form of expression—was something with which Messager felt a great kinship.

Messager's attraction to accessible popular imagery from newspapers and periodicals combines with her interest in the faux and the illusory in *Happiness Illustrated* (*Le Bonheur illustré*), a group of colored-pencil drawings made in 1975 and 1976 (fig. 38). Based on photographic imagery found in slick travel magazines and colorful travel industry brochures, *Happiness Illustrated* refers, in effect, to happiness twice removed: imitations of illustrations of happiness, rendered in what the artist has called "technicolor,"[13] further stressing the synthetic and illusory nature of the drawings. For Messager, illustration is imitative, unoriginal, "reproduced, remade, recopied," and exemplified by these stereotyped, frequently saccharine images.

38. Detail of Happiness Illustrated (Le Bonheur illustré). *1975–76. Installation view, Musée de Grenoble, France, 1989. Colored pencil on paper drawings. Various collections.*

39. Gustave Moreau. The Chimaeras. *1884. Oil on canvas. Musée Gustave Moreau, Paris.*

Several other artists who created photo-based work in the late 1960s and early 1970s were also important to Messager: Gerhard Richter, whose early grisaille paintings fascinated her with their photographic quality, and Sigmar Polke, who, like Messager, began with images from the popular media that he then translated into a vision of reality that is faux or distorted (not in a pejorative sense, but simply in being not true to nature). Messager has also spoken of her admiration at the time for Gilbert and George. They too perceived their lives and art as a seamless whole:

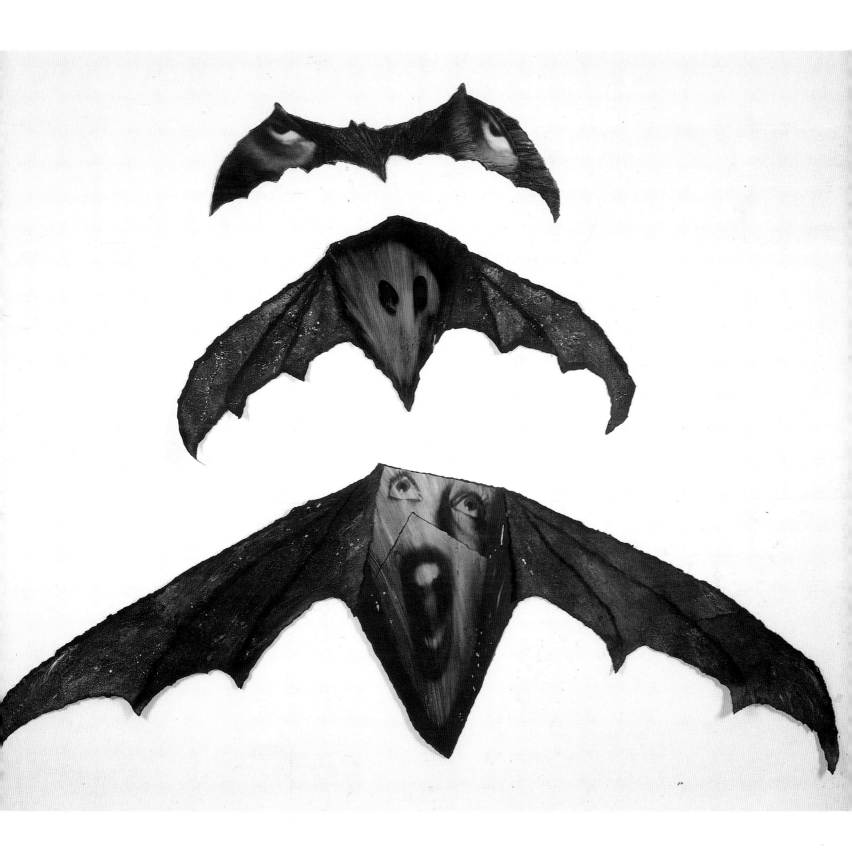

40. Chimaeras (Chimères). *1982. Acrylic and oil on gelatin-silver prints mounted on mesh. Collection the artist.*

Early in her career, Messager met another artist whose work and life are inextricably fused, Joseph Beuys. Messager feels that his desire to create a history or mythology for himself as well as the fact that his work was a part of his life (and vice-versa) strongly link his art and her own.

In her ambitious series *Chimaeras* (*Chimères*) of the early 1980s, in which photography and painting are combined on a grand scale, Messager set out "to make large works on the wall which would be very brilliant, very flashy." Their title refers to both meanings of the word chimaera: the imaginary, usually female, monster of Greek mythology and an illusion or fabrication of the mind; we see very clearly here the conflation of the female and the faux. Messager's *Chimaeras* were specifically inspired by the Symbolist painter Gustave Moreau's grand 1884 canvas *The Chimaeras*, in the Musée Gustave Moreau, Paris (fig. 39). Like the Surrealists in later decades, Moreau was decidedly misogynous, as is evident in his lengthy written commentary on the painting, which begins:

This Isle of Fantastic Dreams encloses all the forms that passion, caprice and
fancy take in women.

Woman, in her primal essence, an unthinking creature, mad on mystery and the
unknown, smitten with evil in the form of perverse and diabolical seduction.[15]

Messager liked the fantasy of Moreau and his contemporaries Odilon Redon and Alfred Kubin and wanted in her own *Chimaeras* (figs. 40 and 43) to combine the fantastic and the horrific with imagery of daily life, particularly imagery associated with women. (For example, women's fear of spiders has become a cliché; Messager herself has a phobia about spiders.) We see in Messager's *Chimaeras* (fig. 42) a spider in her web, surrounded by a constellation of eyes, "like little butterflies, like small flies which the spiders trap." Like Moreau, Redon also created fantastic images of creatures he called chimaeras, in addition to bizarre images of floating eyeballs and of spiders combined with human heads (fig. 41). Spiders are the wily females of the entomological world, luring and killing those who become ensnared in their webs—including at times their own mates. The notion of the spider as female spinner—of tapestries, tales, and webs—goes back to the Greek mythological figure Arachne, the weaver par excellence, who dared to challenge the superiority of the goddess Athena (ironically, the goddess of wisdom) and was turned into a spider as punishment.

The *Chimaeras* are photographs (often distorted) of various body parts, blown up, torn, painted, and mounted on canvas. Messager explains that the notion of fragmenting the human figure has numerous points of reference: "For me, it's a 'natural' gesture to rip bodies apart, cut them up. . . . It's also my desire to reveal scraps, fragments, instants of things; so that there are only a few precious traces, so that the viewer reconstitutes his or her own direction."[16] Fragmented imagery for Messager also relates to her gender: "I always feel that my identity as a woman and as an artist is divided, disintegrated, fragmented, and never linear, always multifaceted . . . always pictures of parts of bodies, fragments

41. Odilon Redon. The Crying Spider. *1881. Charcoal on paper. Private collection, The Netherlands.*

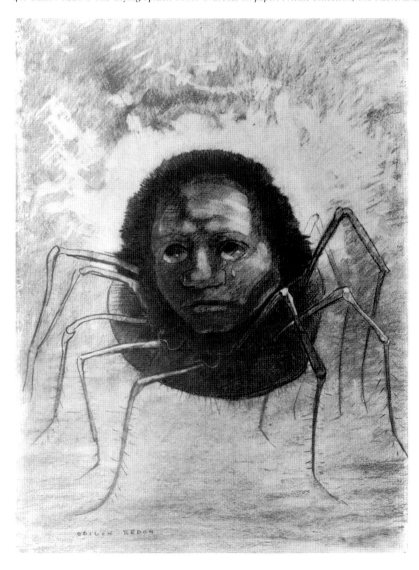

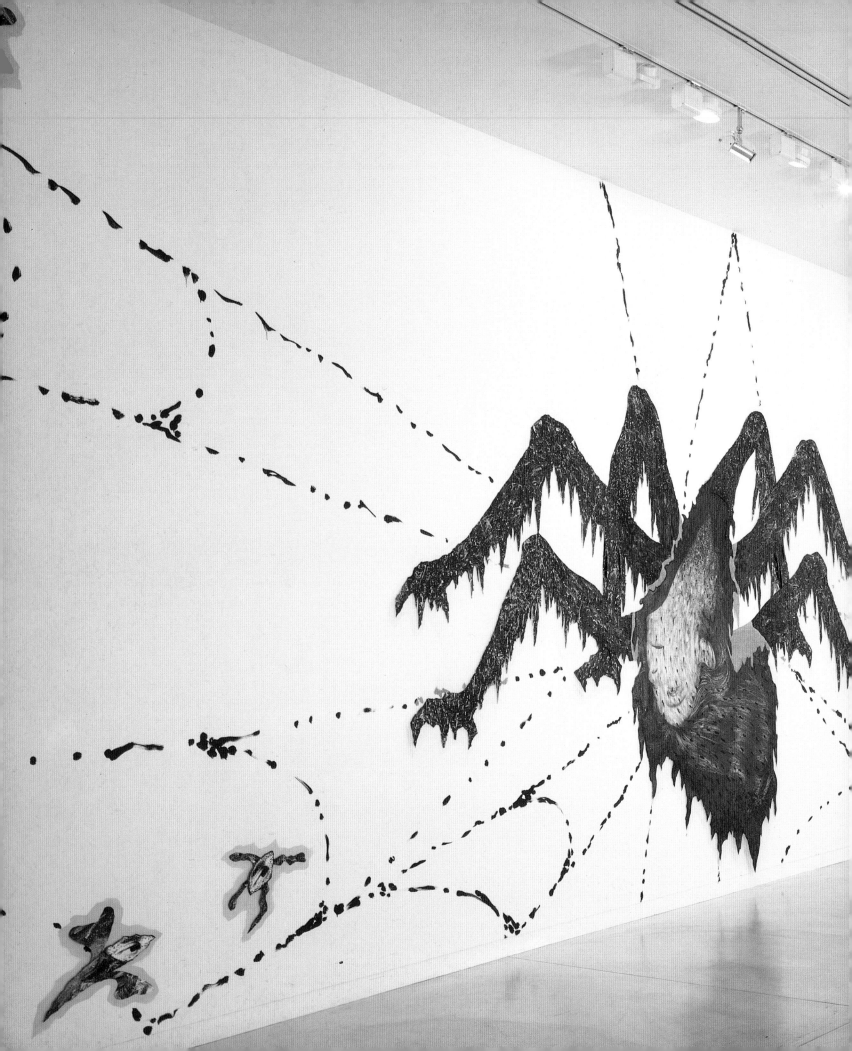

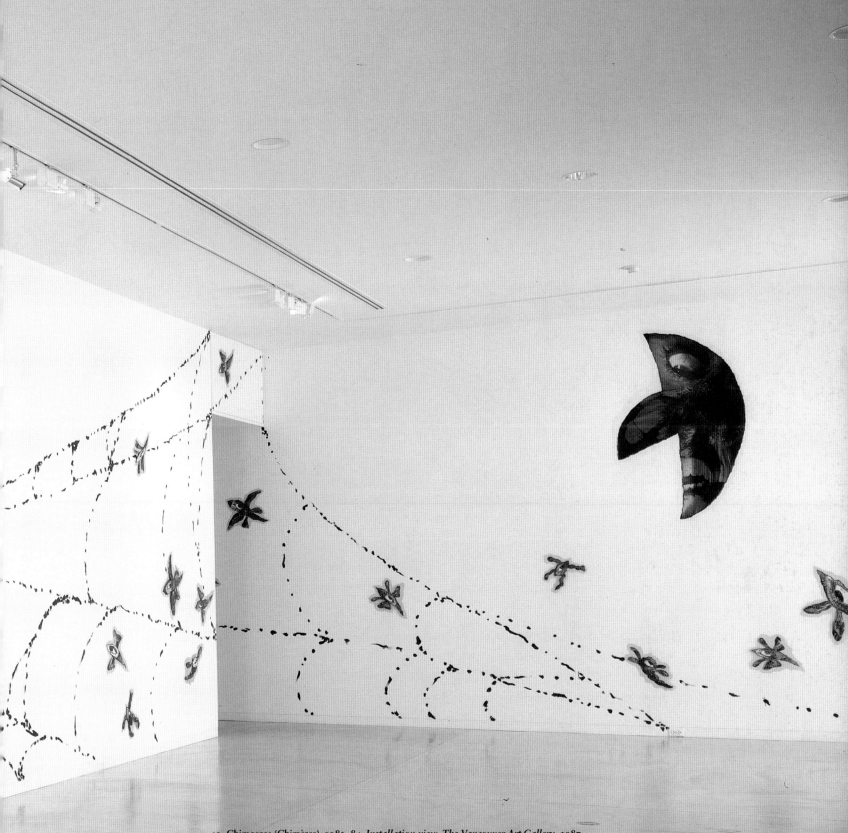

42. Chimaeras (Chimères). 1982–84. *Installation view, The Vancouver Art Gallery, 1987.*
Acrylic and oil on gelatin-silver prints mounted on mesh, and acrylic paint on wall. Collection the artist.

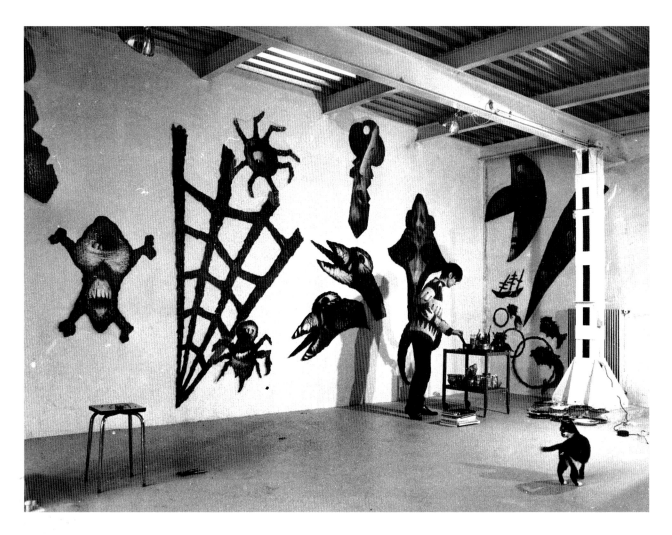

43. *View of Messager's studio with* Chimaeras (Chimères), *Malakoff, France, c.1982.*

and closeups. . . . I always perceive the body in fragments."[17] She has long been interested in medical photography and models, which focus on particular parts of the body, as well as medical specimens of physical phenomena (both ordinary and freakish), which were preserved during the nineteenth and early twentieth centuries not only for medical reasons but also for their entertainment value as displays at fairs and circuses.[18] She has likewise been fascinated by wax, wood, and silver body parts (usually limbs) made as votive offerings and deposited in places of pilgrimage,[19] and she has cited a particular photograph, published in 1930 by Georges Bataille in his Surrealist review *Documents*, depicting a Capuchin mortuary chapel in Rome decorated with the bones of deceased monks (fig. 44).

Perhaps most importantly, the Surrealists often portrayed the human body—the female body—in fragmented form: "Headless. And also footless. Often armless too. . . . There they are, the Surrealist women so [photographed] and painted, so stressed and dismembered, punctured and severed."[20] Surrealist photography particularly fascinates Messager, much more so than Surrealist painting. She has spoken of her admiration for the work of Jacques-André Boiffard (fig. 45), and though she has denied any specific link between Boiffard's work and her own, there seems to be a more than passing resemblance between Boiffard's image of an open mouth (shown in an exhibition of Surrealist photography at the Musée National d'Art Moderne, Paris, in 1985) and Messager's *Pièce montée, no. 2* (1986; fig. 46).[21] Hans Bellmer's powerful photographs (fig. 47), which Messager has termed "very significant" for her own work, show the female body as a mechanical doll, assembled,

44. The cemetery of the Cappuccini, fourth chapel. Chiesa dei Cappuccini, Rome.

disassembled, and reassembled in new forms. (It is of particular import to Messager that Bellmer's photographs are often hand-colored, prefiguring her technique of overpainting photographs.) His images are of woman objectified, toyed with, discarded, scorned—as inherently despicable. In the *Chimaeras*, Messager similarly dissected the human body, using overpainted photographs as her medium; in her work, however, woman is no longer subjugated and defiled.

Messager's fragmentation of the human body continues in her series *My Trophies (Mes Trophées)* of 1986–87. For the artist, the term trophies "is linked to the notion of victory and of death. Hunting trophies or the trophies of Indians: these pieces signify a sort of combat and possession."[22] The imagery of these works grew out of her fascination with French seventeenth-century "maps of tenderness," invented by the writer Madeleine de Scudéry (fig. 48). These are maps of imaginary lands whose features are identified with sentimental designations such as "Lake of Indifference" or "Dangerous Sea." From this imagery Messager developed her own mappings of the human body; on photographs of specific body parts she drew delicate, dreamlike landscapes, figures, flora, and fauna, which emerge out of the "topography" of whorls and wrinkles of skin (fig. 50). The issue of scale is important in *My Trophies*; some images are enormous, far beyond life-size, and others are extremely small. Presenting objects at an unexpected scale, which adds a further sense of the fantastic to the series, was important to the Surrealists as well, as is evident in the photographs of Boiffard or the paintings of René

45. Jacques-André Boiffard. Untitled. 1930. Photograph published in Documents 2, no. 5 (1930), p. 298.

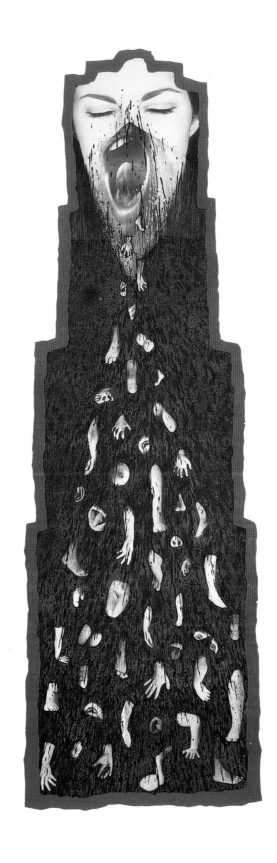

46. Pièce montée, no. 2. *1986. Acrylic and oil on gelatin-silver prints mounted on canvas. Collection the artist.*

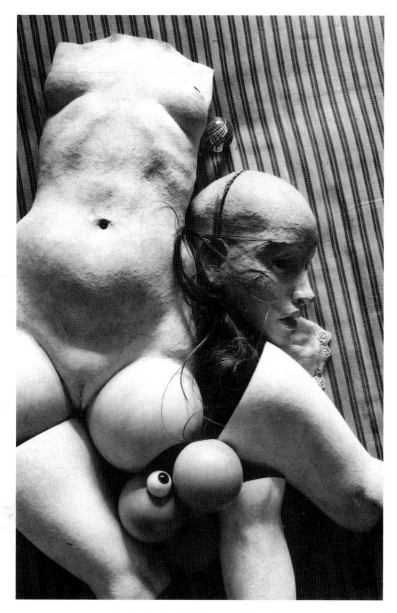

47. *Hans Bellmer. The Doll. 1936. Gelatin-silver print. The J. Paul Getty Museum, Malibu, California.*

Magritte, one of the few Surrealist painters (as opposed to photographers) of interest to Messager (fig. 49). She is attracted to the highly illusionistic nature of his paintings, and she has called him "truly an artist very important to me." She also appreciates Magritte's fragmentation of the human figure (fig. 52), the ordinariness of his subject matter, which nonetheless creates a dreamlike or fantastic mood, and the relationship in his work between image and text, something seen already in Messager's album-collections of the 1970s but which came to the fore in her work in the mid- to late 1980s.

In *My Works (Mes Ouvrages)* (1987; fig. 51), Messager combined word and image in a delicate yet monumental work, which reflects Messager's contact with the work of Sol Lewitt, whose drawings retrospective she had seen at The Museum of Modern Art, New York, in 1978 (fig. 53):

```
I was very struck by [Sol Lewitt's]
wall drawings, with all their pencil
strokes. . . . I have always greatly admired this [work] by Lewitt. . . .
It's something which I found simultaneously monumental and sensitive. That's
what touched me so: to be able to make something almost like a fresco with
just pencils, with such simple means.
```

The small images of *My Works*, photographs of body parts, are woven together by an elaborate skein of text written in colored pencil on the wall. The overall visual effect is of a wall of fine embroidery, reminiscent not only of Lewitt but also of the *art brut* in Dubuffet's collection (see fig. 32). According to Messager, "[*My Works*] has just as much to do with

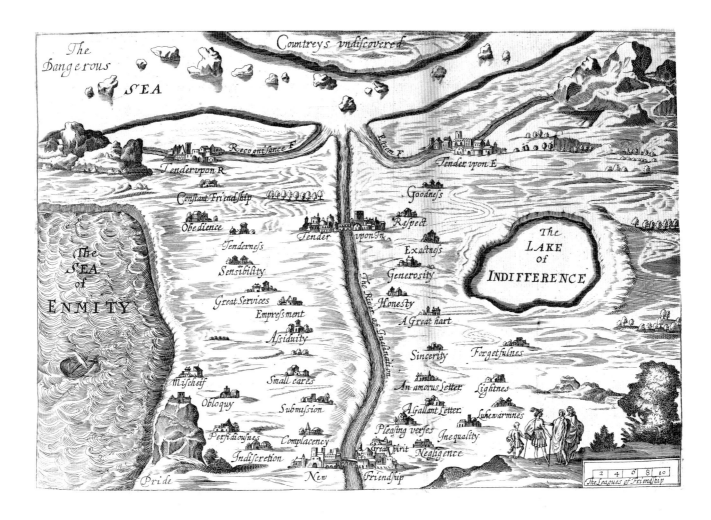

48. *Madeleine de Scudéry.* Map of Tenderness, *frontispiece
from* Clelia, an Excellent New Romance *(London, 1678).
General Research Division, The New York Public Library,
Astor, Lenox and Tilden Foundations.*

49. *René Magritte.* The Treachery of Images. *1928–29.
Oil on canvas. Los Angeles County Museum of Art.
Purchased with funds provided by the Mr. and Mrs. William
Preston Harrison Collection.*

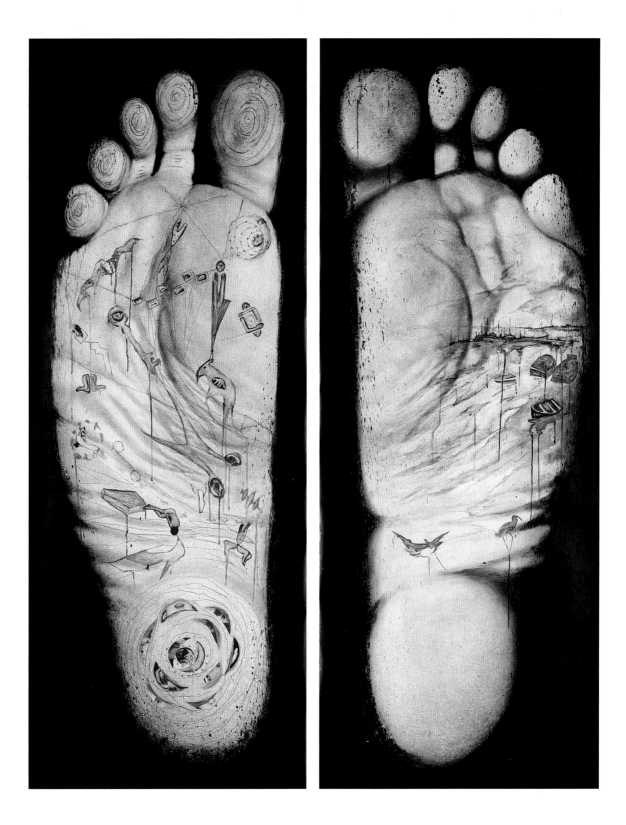

50. My Trophies (Mes Trophées). *1987. Acrylic, charcoal, and pastel on gelatin-silver prints, framed in wood. Collection the artist, courtesy Galerie Chantal Crousel, Paris.*

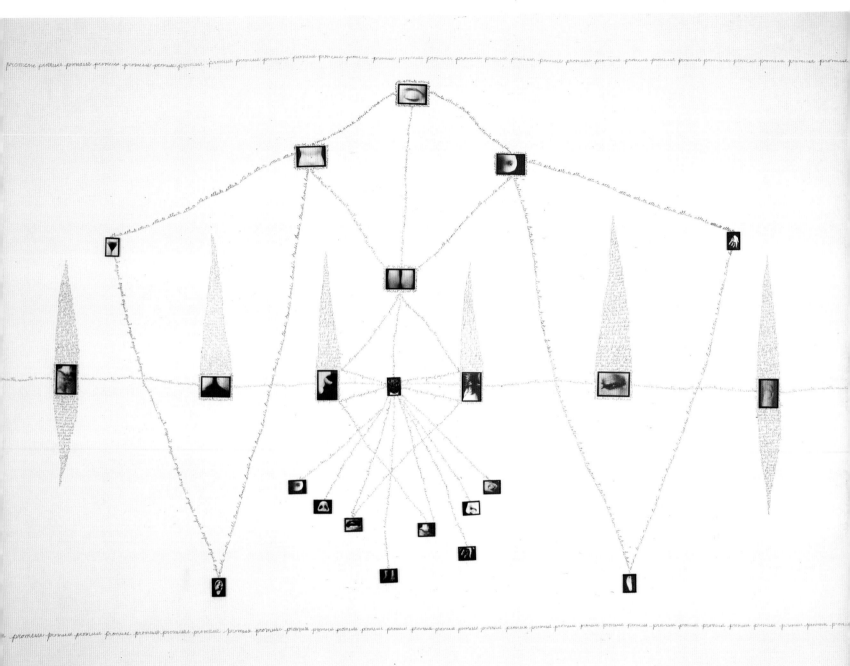

51. My Works (Mes Ouvrages). *1987. Installation view, Le Consortium, Dijon, France, 1988.*
Gelatin-silver prints under glass and colored pencil on wall. Le Consortium, Dijon, France.

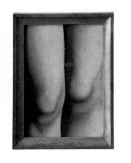

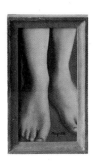

'women's' work as it does with works of art. This can be very grand and very ridiculous at the same time."[23]

The words of *My Works* (and of her other works with texts) describe sentiments or emotional states traditionally associated with women ("fear," "protection," "hesitation," etc.). Messager keeps long lists of words that appeal to her, which she consults when creating her pieces. She has said that there is always some relationship between word and image in her work, but it is generally evident only to her—and even she often forgets the relationship after a piece has been completed. The repetition of the words is important to her: "Repeat[ing] the same word one hundred, two hundred . . . a thousand times, writing it on the wall with colored pencils, you end up obliterating the meaning. . . . [The words] become incantations."[24] Also feeding into the creation of *My Works* was Messager's fascination at this time with medieval illuminated manuscripts, with their delicate combinations of images and texts and what she has described as their spiritual, incantatory nature.

In preparing for her retrospective exhibition organized by the Musée de Grenoble in 1989, Messager was forced to look over the totality of her oeuvre, something she had previously avoided. According to the artist, reconsidering the early *Boarders*, which she had "forgotten," rekindled her interest in working with taxidermized animals as well as stuffed plush toy animals.[25] Out of this renewed interest emerged *My Little Effigies (Mes Petites Effigies)* (1988; see fig. 19). Messager has referred to these as "completely ordinary little dolls to which I . . . attached little photographs and which lie above a pedestal of words. [Yet] these little ridiculous dolls become as terrifying as certain voodoo dolls."[26] The very notion of an effigy—a stand-in for someone, usually a feared or hated person who is vicariously harmed or punished through this effigy—immediately suggests something negative; yet by calling them her *little* effigies, Messager simultaneously casts them in an endearing light. As with the series *Lines of the Hand (Les Lignes de la main)* (1988; see fig. 14), the words here serve visually to support the stuffed animals while describing

52. *René Magritte.* The Eternally Obvious. *1930. Oil on five canvases mounted on Plexiglas. The Menil Collection, Houston.*

53. *Sol Lewitt.* Ten Thousand Lines, Ten Inches Long. *1971. Installation view,* Sol Lewitt, The Museum of Modern Art, *New York, 1978. Pencil on wall. Gilman Paper Co., New York.*

sentiments and emotions traditionally associated with the female ("voluptuousness," "pleasure," "desire," etc.). Small, cuddly, always used, the plush toys suggest but do not depict the children who loved (and possibly abused) them. Each animal is paired with a small photograph of a body part, generally an image of a foot, a hand, an ear, or the like, which is innocuous but nonetheless adds an almost sinister quality to the work. The aura of potent human emotion surrounding these plush toys is indeed reminiscent of the power imbued in voodoo dolls or other fetish figures, also toylike objects believed to have extraordinary powers. Messager emphasized this fetishlike aspect of *My Little Effigies* when she chose to install them in 1989 at the Musée d'Art Moderne de la Ville de Paris along with small-scale African sculptures from the museum's own collection and that of the Musée de l'Homme (see fig. 20).

The aspect of Messager's art that has religion and religious imagery as roots comes to the fore in the series *My Vows (Mes Voeux)* and *Sin (Péché)*. The works comprising *My Vows* (fig. 56, and see figs. 16 and 17) are made up of numerous small black and white photographs of body parts, usually densely hung from strings of varying lengths, partially (or at times completely) obscuring the images. Messager explains the genesis of this series:

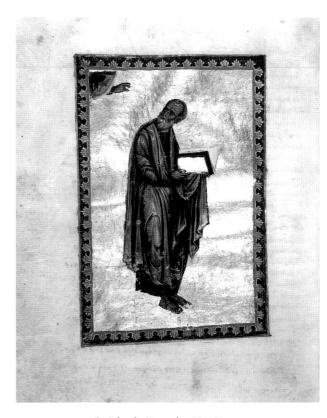

55. St. John the Evangelist. New Testament, Ms. Ludwig II 4, fol. 106v. Constantinople, 1133. Tempera pigment, gold leaf, and gold paint on vellum. The J. Paul Getty Museum, Malibu, California.

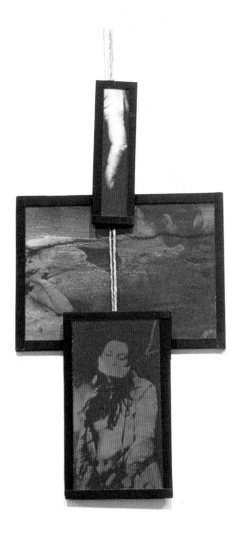

54. Detail of Sin *(Péché) (fig. 57).*

I had made *Lines of the Hand* and *My Trophies*, and I wanted to show parts of the body that were even more fragmented, that were hidden. I didn't know how to do this, when I noticed a string on the ground. . . . If I hang one image on top of another image, that will hide it. And if I hang yet another image on the second image, it will hide that one.

My Vows are Messager's votive offerings, cornucopias of images— straightforward details of the human figure—simultaneously offered yet hidden (see frontispiece). There is here none of the seduction of pornography, yet the fact that many of the images are partially or wholly covered up suggests a certain voyeurism on the part of the viewer. The importance for Messager of Surrealist photography, with its fragmentation of the human body and frequently voyeuristic qualities, is evident once again in *My Vows*.

Sin (1990; figs. 54 and 57) likewise refers to Messager's simultaneous interest in things physical and things spiritual. Comprising numerous small photographs of fingers pointing at overpainted images of women rephotographed from pornographic and sadomasochistic magazines—overpainted to hide the imagery, much as the overlappings

in *My Vows* serve to obscure rather than to clarify—*Sin* stems from Messager's memories of religious education as a young girl and her knowledge of religious imagery:

> 'It's not nice to point,' one says to children. In the Middle Ages, in paintings, in illuminated manuscripts, often a finger emerges from the clouds, like a phallus. This is the finger of God, because he alone has the right to point.[27]

In the Bible (Exodus 33:20–25), God tells Moses that no one can view God's countenance and live but that God shows his presence to man by revealing his hand. The hand as a representation of God is seen, in manuscripts in particular, through the end of the twelfth century (fig. 55).[28]

Messager's title, in combination with the imagery of *Sin*, forces us to address the issue of sin. Are those who perpetrate violence against women the sinners? Are we viewers sinners too, in focusing our attention on (figuratively pointing to) these images? Subtly but powerfully, Messager implicates us all.

In *The Pikes* (*Les Piques*) (1991–93; fig. 58, and see figs. 23 and 24), Messager combined fetishistic imagery and references to vivisection with allusions to current events, the French Revolution, and the role of women in French society. The pike, a polelike weapon with a pointed tip, is a particularly resonant image in French history, as it was the "universally recognized weapon of the sovereign people" during the Revolution,[29] and numerous images exist of revolutionary men and women carrying pikes (fig. 59). "The pikes of the people are the columns of French liberty," wrote the journalist Prudhomme in 1792, but he argued that pikes should be prohibited for women (the right of women to bear arms was much debated at the time): "[L]et them content themselves with being simple spectators."[30] Thus the image of the pike not only makes reference to the French Revolution in general but

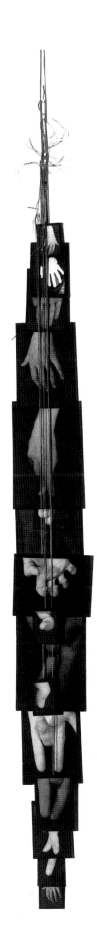

56. My Vows (Mes Voeux). *1988. Sixteen gelatin-silver prints under glass, and string. Collection Ruth and Jacob Bloom.*

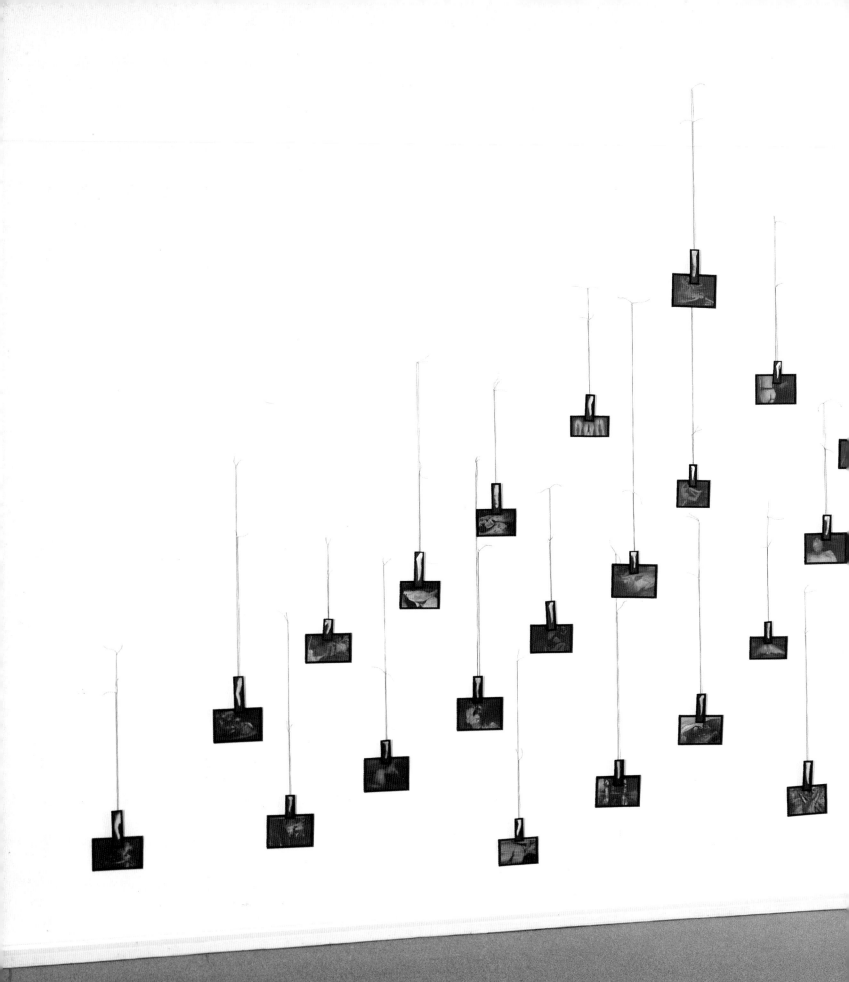

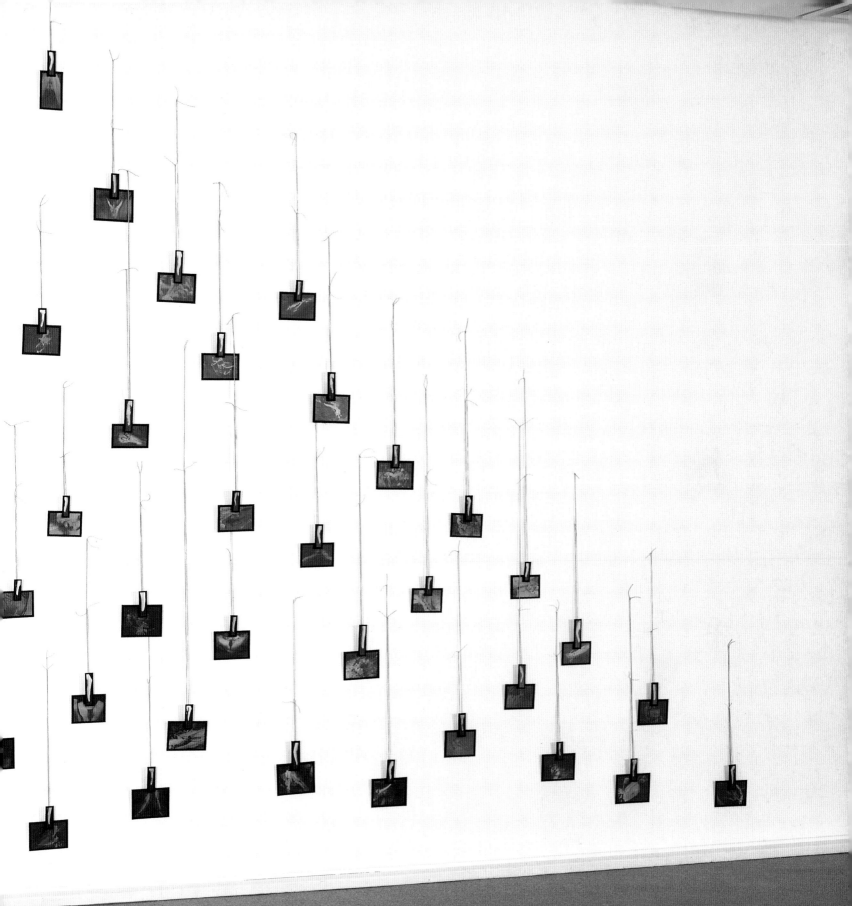

57. Sin (Péché). 1990. *Installation view. Forty-five gelatin-silver prints under glass,*
sixty-three oil on gelatin-silver prints under glass, and string. Collection the artist.

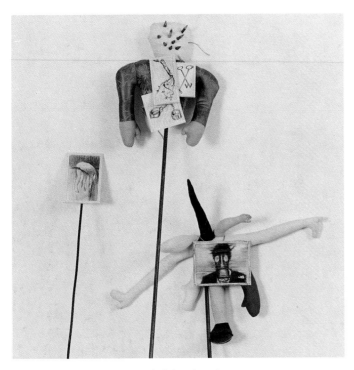

58. *Detail of* The Pikes *(fig. 23).*

also specifically to the issue of women's place in revolutionary society. In addition, the heads of those executed by the guillotine during the Revolution were skewered on pikes and triumphantly displayed. Similarly, various elements in Messager's *Pikes* are impaled, including stuffed figures pierced by numerous colored pencils (with the points protruding), suggesting a form of torture or killing different from the guillotine but equally horrible.

The influences on the work of Annette Messager are many and profound, yet her work is never derivative. She has absorbed and continues to take in a multiplicity of stimuli, transforming and augmenting them through her creative process. Messager herself has described the nature of the varied influences on her work:

> Conceptual art interested me in the same way as the art of the insane, astrology, and religious art. It's not the ideologies which these areas perpetuate that interest me: they are for me, above all else, repertories of forms. I make fun of sorcery and alchemy even if I make full use of their signs.[31]

Often using wit and irony to subvert the ideologies while retaining the formal vocabularies of her sources, Messager has created a distinctive body of work. For her, influence from without (be it the influence of other artists, art movements, *art brut*, advertising, or graffiti) is not limiting and defining but rather liberating and expansive. Like nourishment, it comes in many guises and is both necessary and pleasurable, continually feeding Messager's artistic growth.

59. *Anonymous, French.* French Women Have Become Free. *1790. Colored etching on paper. Bibliothèque Nationale, Paris.*

Notes

1. Unless cited differently, all quotations from the artist are from interviews with the author on 26 and 27 July 1994. Translations into English throughout this essay are by the author unless otherwise noted.

2. According to Messager, because she moved repeatedly during these years and threw things out each time, none of the wooden objects (which she continued to make until the early 1970s) is extant.

3. Jean-Michel Foray, "Annette Messager, collectionneuse d'histoires," *Art Press* 147 (May 1990): 17.

4. "Acquisitions: Entretien avec Annette Messager," interview by Catherine Lawless, *Les Cahiers du Musée National d'Art Moderne* 27 (Spring 1989): 116.

5. Foray, "Annette Messager," 18.

6. For further discussion of this aspect of Surrealism, see Evan Maurer, "Dada and Surrealism," in *"Primitivism" in 20th Century Art: Affinity of the Tribal and the Modern* (New York: The Museum of Modern Art, 1984), 2:535–93; and Roger Cardinal, "Surrealism and the Paradigm of the Creative Subject," in *Parallel Visions: Modern Artists and Outsider Art* (Los Angeles: Los Angeles County Museum of Art, 1992), 94–119.

7. "Annette Messager or the Taxidermy of Desire," interview by Bernard Marcadé, in *Annette Messager, comédie tragédie, 1971–1989* (Grenoble: Musée de Grenoble, 1989), 161.

8. Referring to *The Boarders*, she remarked, "A model frozen in its tracks becomes a fetish of some sort or another." Marcadé, "Annette Messager or the Taxidermy of Desire," 161.

9. "Annette Messager," *Aperture* 130 (Winter 1993): 48.

10. Paul Morand, *Tendres Stocks* (Paris: Gallimard, 1921), 50–51. Messager pointed out this passage to the author, remarking that many years previously she had given fellow artist Christian Boltanski a copy of the book with the passage underscored, to explain her interests to him.

11. *Annette Messager collectionneuse* (Paris: ARC 2, Musée d'Art Moderne de la Ville de Paris, 1974), n.p.

12. See Ted Gott, "Lips of Coral: Sex and Violence in Surrealism," in *Surrealism: Revolution by Night* (Canberra: National Gallery of Australia, 1993), 149.

13. Marcadé, "Annette Messager or the Taxidermy of Desire," 57.

14. Gilbert and George, quoted in "Gilbert & George: Life, a Great Sculpture," in *1985 Carnegie International* (Pittsburgh: Museum of Art, Carnegie Institute, 1985), 136.

15. Quoted in Pierre-Louis Mathieu, *Gustave Moreau* (Boston: New York Graphic Society, 1976), 159.

16. Bernard Marcadé, "Annette Messager," trans. Catherine Liu, *Bomb* (Winter 1988/89): 29.

17. Letter to Marion de Zanger, December 1988, quoted in de Zanger, "Annette Messager: My Work Speaks Simply of the Body," *Ruimte* 6, no. 1 (January 1989): 12.

18. The author and Sheryl Conkelton accompanied Messager in the spring of 1994 to the Musée des Arts Forains in Paris to see its collection of medical specimens.

19. See Sigrid Metken, "Profane Ex-Votos," in *Annette Messager, comédie tragédie, 1971–1989* (Grenoble: Musée de Grenoble, 1989), 152–56.

20. Mary Ann Caws, "Seeing the Surrealist Woman: We Are a Problem," in Caws, Rudolf E. Kuenzli, and Gwen Raaberg, eds., *Surrealism and Women* (Cambridge, Mass.: The MIT Press, 1991), 11.

21. Given Messager's interest in medical photography and models, it is worth noting that Boiffard studied medicine in the 1920s and later had an active practice as a radiologist while working as a photographer and cinematographer.

22. Lawless, "Acquisitions," 111.

23. Marcadé, "Annette Messager," 32.

24. *Ibid.*, 31.

25. The artist most closely associated with the use of stuffed plush toy animals is Mike Kelley, who first used them in his work in 1987. Messager knew Kelley's work as early as 1984, when they both participated in the Sydney Biennale; although both began using stuffed plush toy animals in the late 1980s, they each used them to very different ends.

26. Marcadé, "Annette Messager," 32.

27. Messager's handwritten notes on *Sin*.

28. See Hiltgart L. Keller, "Gott," in *Reclams Lexikon der heiligen und der biblischen Gestalten*, 2d ed. (Stuttgart: Philipp Reclam jun., 1970), 232–33; and Wilhelm Molsdorf, "Gott," in *Christliche Symbolik der Mittelalterlichen Kunst* (Graz: Akademische Druck- u. Verlagsanstalt, 1968), 8–9. My thanks to Mary Levkoff for these references.

29. Darline Gay Levy and Harriet Branson Applewhite, "Women and Political Revolution in Paris," in *Becoming Visible: Women in European History*, 2d ed., ed. Renate Bridenthal, Claudia Koonz, and Susan Stuard (Boston: Houghton Mifflin, 1987), 293. For further discussion of the pike imagery, see text by Jo-Ann Conklin in *in-scapes: Annette Messager* (Iowa City: The University of Iowa Museum of Art, 1992), n.p.

30. Levy and Applewhite, "Women and Political Revolution," 294.

31. Marcadé, "Annette Messager," 32.

Checklist of the Exhibition

Annette Messager was born in 1943 in Berck, France. She lives and works in Malakoff, outside Paris.

The following works are included in the inital showing of the exhibition *Annette Messager* at the Los Angeles County Museum of Art. Works are arranged chronologically, with works in series that extend over a span of more than one year listed together.

Boarders at Rest (Le Repos des pensionnaires). 1971–72. Taxidermized birds and wool, each approximately 4¾ x 4 x 1¼" (12 x 10 x 3 cm). Collection the artist. *Figure 3*

Children with Their Eyes Scratched Out (Les Enfants aux yeux rayés), Album-collection No. 3. 1971–72. Ink on five gelatin-silver prints, each 14 x 19½" (35.5 x 49.5 cm), and one album. Musée d'Art Moderne de la Ville de Paris. *Figures 6 and 7*

Approaches (Les Approches), Album-collection No. 8. 1972. Pencil on four gelatin-silver prints (two 10⅝ x 22" [27 x 56 cm], one 10⅝ x 28⅜" [27 x 72 cm], one 10⅝ x 33½" [27 x 85 cm]), and one album. Collection the artist, courtesy Galerie Chantal Crousel, Paris.

Collection to Find My Best Signature (Collection pour trouver ma meilleure signature), Album-collection No. 24. 1972. Ninety-two ink on paper drawings, each 9⅞ x 7½" (25 x 19 cm), and one album. Collection the artist. *Figure 34*

How My Friends Would Do My Portrait (Comment mes amis me feraient mon portrait), Album-collection No. 23. 1972. Sixty-two ink on paper drawings (thirteen 5⅛ x 3½" [13 x 9 cm], sixteen 7⅛ x 4¾" [18 x 12 cm], thirty-three 7⅞ x 5½" [20 x 14 cm]), fifty-five gelatin-silver prints (forty-two 3½ x 3⅝" [9 x 9 cm], thirteen 4⅜ x 3⅞" [11 x 10 cm]), and one album. Courtesy Galerie Chantal Crousel, Paris. *Figure 33*

My Needlework (Mes Travaux d'aiguilles), Album-collection No. 7. 1972. Twenty-four fabric, thread, and ink on paper elements, each 10 x 16¾" (25.5 x 42.5 cm), and one album. Musée de Grenoble. *Figure 36*

Voluntary Tortures (Les Tortures volontaires), Album-collection No. 18. 1972. Eighty-six gelatin-silver prints, each 11¾ x 7⅞" (30 x 20 cm), and one album. The Sandor Family Collection. *Figure 9 shows another version*

Handbook of Everyday Magic (Petite Pratique Magique quotidienne), Album-collection No. 47. 1973. Thirty-two mixed-medium on paper elements, each 10⅝ x 9¼" (26.5 x 23.5 cm), and one album. Courtesy Galerie Chantal Crousel, Paris. *Figures 4 and 5*

My Collection of Proverbs (Ma Collection de proverbes). 1974. Sixty fabric and thread elements, each 13¾ x 11" (35 x 28 cm). Collection the artist. *Figure 8*

The Horrifying Adventures of Annette Messager, Trickster (Les Effroyables Aventures d'Annette

Messager truqueuse). 1974–75. Sixty-four gelatin-silver prints, mounted irregularly and framed (overall dimensions 106¼ x 129⅞" [270 x 330 cm]), and thirty-seven ink on paper drawings glued inside paper folders, each 12⅝ x 9½" (32 x 24 cm). Collection the artist, courtesy Galerie Chantal Crousel, Paris. *Figure 10*

Happiness Illustrated (Le Bonheur illustré). 1975–76. Thirty colored pencil on paper drawings, each 11¾ x 16½" (30 x 42 cm). Galerie Chantal Crousel, Paris; Galerie Laage-Salomon, Paris; and collections Chantal Crousel, Gabrielle Salomon, Nancy and Elise de la Selle, and Tracy Williams. *Figure 38*

Chimaeras (Chimères) (small flying eyes). 1982. Seventeen acrylic and oil on gelatin-silver prints mounted on mesh; dimensions variable (maximum 31¾ x 28½" [80.6 x 72.4 cm]; minimum 15 x 14¼" [38.1 x 36.2 cm]). Collection the artist.

Chimaeras (Chimères) (spider with web). 1982. Acrylic and oil on gelatin-silver print mounted on mesh, and acrylic paint on wall, 15¾ x 15¾" (40 x 40 cm). Collection the artist.

Chimaeras (Chimères) (three bats). 1982. Three acrylic and oil on gelatin-silver prints mounted on mesh, overall 96½ x 110¼" (245 x 280 cm). Collection the artist. *Figure 40*

Chimaeras (Chimères) (tree no. 52). 1983. Acrylic and oil on gelatin-silver print mounted on mesh, 114⅛ x 86⅝" (290 x 220 cm). Collection the artist.

My Trophies (Mes Trophées) (buttocks/death head). 1986. Acrylic, charcoal, and pastel on gelatin-silver print, framed in wood, 10¼ x 11⅜" (26 x 29 cm). Collection the artist.

My Trophies (Mes Trophées) (snake/mouth). 1986. Acrylic, charcoal, and pastel on gelatin-silver print, framed in wood, 6¾ x 6¼" (17 x 16 cm). Collection the artist.

My Trophies (Mes Trophées) (left foot and right foot). 1987. Acrylic, charcoal, and pastel on gelatin-silver prints, framed in wood, overall 81⅛ x 67" (206 x 170 cm). Collection the artist, courtesy Galerie Chantal Crousel, Paris. *Figure 50*

My Works (Mes Ouvrages). 1987. Gelatin-silver prints under glass (each 5⅛ x 3½" [13 x 9 cm] or 2⅜ x 3½" [6 x 9 cm]) and colored pencil on wall, overall dimensions variable. Collection the artist. *Figure 15 (figure 51 shows another version)*

Lines of the Hand ("Fear") (Les Lignes de la main ["Crainte"]). 1987. Acrylic, charcoal, and pastel on gelatin-silver print, framed in wood (8⅞ x 6⅞" [22.5 x 17.5 cm]), and colored pencil on wall, overall dimensions variable. Collection the artist.

Lines of the Hand ("Hesitation") (Les Lignes de la main ["Hésitation"]). 1987. Acrylic, charcoal, and pastel on gelatin-silver print, framed in wood (14 x 11¼" [35.6 x 28.6 cm]), and colored pencil on wall, overall dimensions variable. Collection the artist.

Lines of the Hand ("Protection") (Les Lignes de la main ["Protection"]). 1987. Acrylic, charcoal, and pastel on gelatin-silver print, framed in wood (9⅜ x 7" [23.8 x 17.8 cm]), and colored pencil on wall, overall dimensions variable. Collection the artist.

Lines of the Hand ("Rumor") (Les Lignes de la main ["Rumeur"]). 1987. Acrylic, charcoal, and pastel on gelatin-silver print, framed in wood (11⅞ x 8¾" [30.2 x 22.2 cm]), and colored pencil on wall, overall dimensions variable. Collection the artist.

Lines of the Hand ("Tolerance") (Les Lignes de la main ["Tolérance"]). 1988. Acrylic, charcoal, and pastel on gelatin-silver print, framed in wood (32¼ x 18½" [81.9 x 47 cm]), and colored pencil on wall, overall dimensions variable. Weil, Gotshal & Manges.

Lines of the Hand ("Trust") (Les Lignes de la main ["Confiance"]). 1988. Acrylic, charcoal, and pastel on gelatin-silver print, framed in wood (27⅛ x 18" [68.9 x 45.7 cm]), and colored pencil on wall, overall dimensions variable. The Neuberger & Berman Collection.

My Little Effigies (Mes Petites Effigies). 1988. Ten plush toys, gelatin-silver prints under glass, and colored pencil on wall, overall dimensions variable. Collection Steven Johnson and Walter Sudol. *Figure 19*

My Little Effigies (Mes Petites Effigies). 1988. Twelve plush toys, gelatin-silver prints under glass, and colored pencil on wall, overall dimensions variable. Collection Ruth and Jacob Bloom.

My Vows (Mes Voeux). 1988. Sixteen gelatin-silver prints under glass, and string, overall 117¾ x 6¼" (299 x 16 cm). Collection Ruth and Jacob Bloom. *Figure 56*

My Vows (Mes Voeux). 1988–91. Eleven pairs of framed colored pencil drawings and text on paper under glass (each pair 8 x 5½" [20.3 x 14 cm]), and string, overall 114 x 90½" (289.6 x 229.9 cm). Collection Clyde and Karen Beswick, Los Angeles. *Figure 28*

My Vows (Mes Voeux). 1988–91. Gelatin-silver prints under glass, and string, overall approximately 140 x 78" (356 x 198 cm). The Museum of Modern Art, New York. Gift of The Norton Family Foundation. *Figure 16*

My Vows (Mes Voeux). 1989. Colored pencil on paper, gelatin-silver prints under glass, and string, overall 118⅛ x 39⅜" (300 x 100 cm). Collection the artist, courtesy Galerie Chantal Crousel, Paris.

Sin (Péché). 1990. Forty-five gelatin-silver prints under glass, sixty-three oil on gelatin-silver prints under glass, and string; maximum size of print 5 x 7" (12.7 x 17.8 cm); minimum size of print 3⅛ x 1" (7.9 x 2.54 cm); overall dimensions variable. Collection the artist. *Figures 54 and 57*

The Story of Little Effigies (Histoire des petites effigies). 1990. Forty plush toys and eleven framed

collages, each with doll clothing and charcoal on gelatin-silver print under glass; collages in two sizes: 12⅝ x 6⅞" (32 x 17.5 cm) and 9½ x 5¾" (24 x 14.5 cm); overall dimensions variable. Collection the artist. *Figure 18 shows another version*

The Story of Dresses (Histoire des robes) (green dress with eight heart motif drawings). 1990. Dress, watercolor on paper, string, and safety pins in glass and wood box, 11¹³⁄₁₆ x 51³⁄₁₆ x 3½" (30 x 130 x 9 cm). Collection the artist, courtesy Galerie Chantal Crousel, Paris.

The Story of Dresses (Histoire des robes) (black dress with ten drawings of bonelike forms). 1990. Dress, ink and wash on paper, string, and safety pins in glass and wood box, 11¹³⁄₁₆ x 51³⁄₁₆ x 3½" (30 x 130 x 9 cm). Collection the artist.

The Story of Dresses (Histoire des robes) (black and pink dress with photographs of tortures). 1990. Dress, oil on gelatin-silver prints, string, and safety pins in glass and wood box, 11¹³⁄₁₆ x 51³⁄₁₆ x 3½" (30 x 130 x 9 cm). Collection the artist.

The Story of Dresses (Histoire des robes) (white dress with clown drawing). 1990. Dress, watercolor on paper, string, and safety pins in glass and wood box, 11 x 36⅝ x 3½" (27.9 x 93 x 9 cm). Collection the artist.

The Story of Dresses (Histoire des robes) (white dress with drawings of letters that spell "Promesse"). 1990. Dress, watercolor on paper, string, and safety pins in glass and wood box, 11¹³⁄₁₆ x 51³⁄₁₆ x 3½" (30 x 130 x 9 cm). Galerie Chantal Crousel, Paris.

The Story of Dresses (Histoire des robes) (blue dress with drawings of signs of happiness). 1990. Dress, crayon on paper, string, and safety pins in glass and wood box, 11¹³⁄₁₆ x 62½ x 3¼" (30 x 158.8 x 8.3 cm). Collection the artist. *Figure 22*

The Story of Dresses (Histoire des robes) (black dress with fifteen watercolors). 1990. Dress,

watercolor on paper, string, and safety pins in glass and wood box, 11⁵⁄₁₆ x 51⅛ x 3½" (28.7 x 129.9 x 8.3 cm). Collection the artist.

The Story of Dresses (Histoire des robes) (white dress with photograph of face). 1990. Dress and gelatin-silver print mounted on canvas in glass and wood box, 11¹³⁄₁₆ x 62¼ x 3¼" (30 x 158.1 x 8.3 cm). Collection the artist.

The Story of Dresses (Histoire des robes) (white dress with drawings of words). 1990. Dress, colored pencil on paper, string, and safety pins in glass and wood box, 11⅞ x 51¼ x 3¼" (30.2 x 129.9 x 8.3 cm). Collection the artist.

The Story of Dresses (Histoire des robes) (pink dress with drawings that spell "Innocence"). 1990. Dress, watercolor on paper, string, and safety pin in glass and wood box, 11 x 36⅝ x 3¼" (17.9 x 93 x 8.3 cm). Collection the artist.

The Story of Dresses (Histoire des robes) (black dress with three pairs of photographs of body parts). 1990. Dress, gelatin-silver prints, string, and safety pins in glass and wood box, 11 x 36⅝ x 3¼" (17.9 x 93 x 8.3 cm). Collection the artist.

The Story of Dresses (Histoire des robes) (black dress with photograph of distorted face). 1991. Dress and gelatin-silver prints mounted on canvas in glass and wood box, 11⅞ x 62¼ x 3¼" (42.7 x 158.1 x 8.3 cm). Collection the artist.

The Story of Dresses (Histoire des robes) (black dress with photographs). 1991. Dress, gelatin-silver prints, string, and safety pins in glass and wood box, 11¾ x 51³⁄₁₆ x 3¼" (29.8 x 130 x 8.3 cm). Collection the artist, courtesy Galerie Chantal Crousel, Paris.

The Story of Dresses (Histoire des robes) (black, gray, and white dress with nine drawings). 1991. Dress, ink on paper, string, and safety pins in glass and wood box, 11 x 36⅝ x 3¼" (17.9 x 93 x 8.3 cm). Collection the artist.

The Story of Dresses (Histoire des robes) (orange dress with dark braid and blue ribbon). 1991. Dress, hair, and ribbon in glass and wood box, 11 x 36⅝ x 3¼" (17.9 x 93 x 8.3 cm). Collection the artist.

The Story of Dresses (Histoire des robes) (green dress with watercolor). 1991. Dress, watercolor on paper, string, and safety pin in glass and wood box, 11 x 36⅝ x 3¼" (17.9 x 93 x 8.3 cm). Collection the artist, courtesy Galerie Chantal Crousel, Paris.

Attack of the Colored Pencils (L'Attaque des crayons de couleurs). 1991. Colored pencils embedded in wall, variable dimensions. Collection the artist.

The Pikes (Les Piques). 1991–93. Parts of dolls, fabric, nylons, colored pencils, colored pencil on paper under glass, and metal poles, overall 118 x 354" (300 x 900 cm). Musée National d'Art Moderne, Centre Georges Pompidou, Paris; and collections Michael Harris Spector and Dr. Joan Spector, and the artist. *Figures 2, 23, 24, and 58*

Nameless Ones (Anonymes). 1993. Twenty-three taxidermized animals with stuffed animal heads, gelatin-silver prints under glass, and metal poles in clay bases, overall 354⅝ x 196⅝" (900 x 500 cm). Collection contemporaine du Musée Cantini, Marseille. *Figure 1*

Penetration (Pénétration). 1993–94. Fifty sewn and stuffed fabric elements, and angora yarn; maximum size of individual element 45¼ x 16½" (115 x 42 cm); minimum size of individual element 5½ x 4" (14 x 10 cm); overall dimensions variable. Collection the artist, courtesy Monika Sprüth Galerie, Cologne. *Figure 26*

Untitled (Sans titre). 1993–95. Mosquito netting, stuffed and taxidermized animals, fabric, and string, overall dimensions variable. Collection the artist. *Figure 25*

Solo Exhibitions

Mes Jeux de main par Annette Messager truqueuse, Galerija Suvremene Umjetnosti, Zagreb, Yugoslavia.

1976
Christian Boltanski/Annette Messager: Modell-bilder, das Glück, die Schönheit und die Traüme, Rheinisches Landesmuseum, Bonn.
Galerie Grafikmeyer, Karlsruhe, Germany.
Galerie Multimedia, Erbusce, Italy.

1977
Annette Messager 'Les Vacances,' Centre d'Art et de Communications, Vaduz, Liechtenstein.
Galerie Isy Brachot, Brussels.
Modellbilder/Images modèles, Galerie Seriaal, Amsterdam.

1978
Annette Messager Kolecje, 1972–1975, B.W.A., Lublin, and Salon Krytykow, Czervic, Poland.
Die Fortsetzungsromane mit Annette Messager Sammlerin, Annette Messager praktische

1973
Annette Messager collectionneuse—Mes Clichés-Témoins, Galerie Yellow Now, Liège, France.
Annette Messager Sammlerin; Annette Messager Künstlerin, Städtische Galerie im Lenbachhaus, Munich.

1974
Annette Messager collectionneuse, Musée d'Art Moderne de la Ville de Paris.
Annette Messager collezionista, Galleria Diagramma, Milan.
Daner Galleriet, Copenhagen.
Galerie Sankt-Petri, Lund, Sweden.

1975
Annette Messager collectionneuse, artiste, truqueuse, femme pratique, Galleria Diagramma, Milan.
La Femme et . . . Annette Messager truqueuse, Galerie Ecart, Geneva.
Galerie Space, Wiesbaden, Germany.
Galerie 't Venster, Rotterdam.

Hausfrau, Annette Messager trickreiche Frau, Annette Messager Künstlerin, Rheinisches Landesmuseum, Bonn.
Serials, Galerie Foksal, Warsaw.
Serials, Annette Messager, Holly Solomon Gallery, New York.

1979
Galerie Gillespie-Laage, Paris.

1980
Annette Messager, Galerie Maeght, Zurich.
Galerie Gillespie-Laage, Paris.
Galerie Le Coin du Miroir, Dijon, France.
St. Louis Art Museum, St. Louis, Missouri.

1981
Annette Messager, Photo/Drawing, Wall Assemblage, Fine Arts Gallery, University of California, Irvine.
P. S. 1, Long Island City, New York.
San Francisco Museum of Modern Art.

1982
Annette Messager: Statements New York 82,
Holly Solomon Gallery, New York.
Les Variétés, Artists Space, New York.
Les Variétés, Galerie Denise Réné Hans Meyer,
Düsseldorf.

1983
Annette Messager/Chimères 1982–1983, Musée
des Beaux-Arts, Calais.
Galerie Gillespie-Laage-Salomon, Paris.

1984
Annette Messager, chimères, Galerie Grita Insam,
Vienna.
Galerie Elisabeth Kaufmann, Zurich.
Les Pièges à chimères d'Annette Messager, Musée
d'Art Moderne de la Ville de Paris.

1985
Chimères, Riverside Studios, Hammersmith,
London.
Effigies, 1984–1985, Galerie Gillespie-Laage-
Salomon, Paris.

1986
Annette Messager: Peindre, photographier,
Galerie d'Art Contemporain, Direction des
Musées de Nice, France.
Artspace Visual Arts Center, Surrey Hills, Australia.

1987
Annette Messager, The Vancouver Art Gallery.
Art Space of Sydney.
Mes Trophées, Galerie Elisabeth Kaufmann,
Zurich.

1988
Annette Messager: Comédie tragédie, Centre
d'Art Contemporain, Castres, France.
Le Consortium, Centre d'Art Contemporain,
Dijon, France.
Galerie Wanda Reiff, Maastricht, The
Netherlands.
Mes Trophées, Galerie Laage-Salomon, Paris.

1989
Annette Messager, comédie tragédie, 1971–1989,
Musée de Grenoble, France. (Traveled to Bonner
Kunstverein, Bonn; Musée de la Roche-sur-Yon,
France; Kunstverein für die Rheinlände und
Westfalen, Düsseldorf.)
Annette Messager, mes ouvrages, Saint-Martin du
Méjean, Arles, France.
Mes Enluminures, Galerie Crousel-Robelin
BAMA, Paris.

1990
Contes d'été, Musée Départemental, Château de
Rochechouart, France.
Faire des histoires, Galerie Crousel-Robelin
BAMA, Paris.
Galerie Elisabeth Kaufmann, Basel.

1991
*Annette Messager: Faire des histoires/Making Up
Stories*, Mercer Union and Cold City Gallery,
Toronto. (Traveled to Mendel Art Gallery,
Saskatoon, Canada; Presentation House Gallery
and Contemporary Art Gallery, Vancouver.)
Galerie Wanda Reiff, Maastricht, The Netherlands.

1992
Annette Messager, Kunstverein, Salzburg,
Austria.
Annette Messager, Telling Tales, Arnolfini,
Bristol, and Cornerhouse, Manchester, England.
(Traveled to Camden Arts Centre, London; The
Douglas Hyde Gallery, Trinity College, Dublin.)
Des Hauts et des bas, private exhibition, Paris.
in-scapes: Annette Messager, The University of
Iowa Museum of Art, Iowa City.
Monika Sprüth Galerie, Cologne.

1993
Faire Figures, Fonds Régional d'Art
Contemporain Picardie, Amiens, France.
Les Piques, Josh Baer Gallery, New York.

1994
Die Fotografie im Werke von Annette Messager,
Galerie Elisabeth Kaufmann, Basel.
Penetration, Monika Sprüth Galerie, Cologne.

1995
Annette Messager, Los Angeles County Museum
of Art and The Museum of Modern Art, New
York. (Traveling to The Art Institute of Chicago.)
Archives Librairie Jean-Dominique Carré, Paris.
Faire parade, Musée d'Art Moderne de la Ville de
Paris.
Galerie Foksal, Warsaw.

Selected Group Exhibitions

1972
French Widow, Galerija Studentskog Centre,
Zagreb, Yugoslavia.
Wool Art—36 Artistes de la laine, Galerie
Germain, Paris.

1973
*Christian Boltanski, Jean Le Gac, Annette
Messager*, Biennale des Nuits de Bourgogne,
Musée Rude, Dijon, France.
Cinq Musées personnels, Musée de Peinture et de
Sculpture, Grenoble, France.
Les Travaux de l'atelier, Musée Rude, Dijon,
France.

1974
Ils collectionnent, Musée des Arts Décoratifs, Paris.
(Traveled to Musée des Arts Décoratifs, Montreal.)

1975
Je/Nous, Musée d'Ixelles, Brussels.
New Media, Malmö Konsthall, Malmö, Sweden.

1976
Biennale di Venezia, Venice.
Les Boîtes, Musée d'Art Moderne de la Ville de
Paris. (Traveled to Maison de la Culture, Rennes,
France.)
Foto & Idea, Galleria Communale d'Arte
Moderna, Parma, Italy.
Frauen machen Kunst, Galerie Magers, Bonn.
(Traveled to Kunstverein, Wolfsburg, Germany.)

Identité-Identification, Centre d'Arts Plastiques
Contemporains, Musée d'Art Contemporain,
Bordeaux, France. (Traveled to Théâtre National
de Chaillot, Paris.)
*La Photographie comme art, l'art comme pho-
tographie*, Maison Européenne de la Photogra-
phie, Chalon-sur-Saône, France, and
Gesamthochschule, Kassel, Germany.
Trois Villes, trois collections. Le Henaff, Saint-
Étienne, France.

1977
Beethoven, Music for the Millions, The
Netherlands Stitching Festival, Arnhem.
Bookworks, The Museum of Modern Art, New
York.
Dixième Biennale de Paris, Centre National de la
Photographie, Palais de Tokyo, Paris. (Traveled to
Musée de Nice, France; Musée d'Art Moderne,
Strasbourg, France.)
Documenta 6, Kassel, Germany.
Galerie Gillespie-Laage, Paris.
Künstlerinnen international 1877/1977, Schloss
Charlottenburg, Berlin.
Magna, Museo Castelvecchio, Verona, Italy.
Matisse et les artistes contemporains, Museum
van Hedendaagse Kunst, Ghent, Belgium.
Selbstporträt, Künstlerhaus, Stuttgart.
Symposium Franco-Allemande, Bordeaux/Aix-la-
Chapelle, France.

Trois Villes, trois collections, Musée Cantini,
Marseille. (Traveled to Musée de Peinture et de
Sculpture, Grenoble; Musée d'Art et d'Industrie,
Saint-Etienne, France; Musée National d'Art
Moderne, Centre Georges Pompidou, Paris.)

1978
Couples, P. S. 1, Long Island City, New York.

1979
Dix Ans d'art en France, Musée d'Art Moderne
de la Ville de Paris.
*Tendances de l'art en France III, 1968–1978/79,
partis-pris autres*, Musée d'Art Moderne de la
Ville de Paris.
The Third Biennale of Sydney: European Dialogue,
Art Gallery of New South Wales, Sydney.
Artist's Books, Galerie Lydia Megert, Bern,
Switzerland.
Photography as Art, Institute of Contemporary
Art, London.
*Umrisse: Bilder, Objecte, Videos, Filme von
Künstlerinnen*, Kunsthalle and Kunstverein, Kiel,
Germany.
Trigon 79: Masculin/Féminin, Künstlerhaus,
Graz, Austria.
Eremit? Forscher? Sozialarbeiter? Kunstverein
and Kunsthaus, Hamburg.
Words, Museum Bochum, Bochum, Germany.
(Traveled to Palazzo Ducale, Genoa.)
French Art 1979, Serpentine Gallery, London.

1980

Artist and Camera, exhibition organized by the British Council. (Traveled to Mappin Art Gallery, Sheffield; Stoke City Art Gallery, Stoke; D.L.I. Museum and Art Centre, Durham; Cartwright Hall, Bradford, England.)
Biennale di Venezia, Venice.
FIAC 80, Paris.
Ils se disent peintres, ils se disent photographes, Musee d'Art Moderne de la Ville de Paris.
Walls! Contemporary Arts Center, Cincinnati.
Zorn und Zürtlichkeit, Galerie Maeght, Zurich.

1981

Art & Culture, Kunstverein, Stuttgart.
Autoportraits photographiques 1898–1981, Musée National d'Art Moderne, Centre Georges Pompidou, Paris.
37 aktuella Konstnärer fran Frankrike, Liljevalchs Konsthall, Stockholm.
Façons de peindre, Maison de la Culture, Chalon-sur-Saône, France. (Traveled to Musée Rath, Geneva; Musée Savoisien, Chambéry, France.)
Toyama Now 1981: For a New Art, Museum of Modern Art, Toyama, Japan.
Typische Frau, Bonner Kunstverein and Galerie Magers, Bonn. (Traveled to Städtische Galerie, Regensburg, Germany.)

1982

Art d'aujourd'hui et érotisme, Kunstverein, Bonn.
De Matisse à nos jours: Tendances de l'art dans la région Nord-Pas-de-Calais depuis 1945, Musée des Beaux-Arts de Lille, France.
Kunst i Frankrike, Bergens Kunstferning, Bergen, Norway.
Le Poids des mots/Le Choc des photos, Au Fond de la Cour à Droite, Chagny, France.
Statements 1, Barbara Gladstone Gallery, New York.
Works with Photos, Galerie Pennings, Eindhoven, The Netherlands.

1983

Anniversaire de l'OFAJ, Kunstverein, Bonn.
Kunst mit Photographie, Nationalgalerie, Staatliche Museen Preussischer Kulturbesitz, Berlin. (Traveled to Kunstverein, Cologne; Stadtmuseum, Munich; Kunsthalle and Kunstverein, Kiel, Germany.)
New Art at the Tate Gallery 1983, Tate Gallery, London.
Noeuds et ligatures, Fondation Nationale des Arts Graphiques et Plastiques, Paris.
Rupture, pas rupture, Centre Culturel Le Parvis, Ibos-Tarbes, France.

1984

L'Art à l'oeuvre, Ecole Régionale des Beaux-Arts d'Angers, France.
Contiguïté, de la photographie à la peinture, Centre National de la Photographie, Palais de Tokyo, Paris.
Deux Régions en France: L'Art international d'aujourd'hui, Palais des Beaux-Arts, Charleroi, Belgium.

Écritures dans la peinture, Villa Arson, Nice.
The Fifth Biennale of Sydney: Private Symbol, Social Metaphor, Art Gallery of New South Wales, Sydney.
FR.IT.ES, Axe Art Actuel, Toulouse, France.
Lumières et sons 84, Château Biron, Dordogne, France.
Märchen, Mythen, Monster, Rheinisches Landesmuseum, Bonn. (Traveled to Kunstmuseum, Thun, Switzerland.)

1985

Alles und noch viel Mehr, Kunsthalle, Bern, Switzerland.
Biennale des Friedens—Finding a Form for Peace, Kunstverein and Kunsthaus, Hamburg.
Ceci n'est pas une photographie, Hôtel du Département, Mont-de-Marsan, France. (Traveled to Fonds Régional d'Art Contemporain Aquitaine, France.)
Collections, L'Elac, Lyon, France.
Dialog, Moderna Museet, Stockholm.
D'une loge à l'autre, L'Opéra de Paris.
Lisières et mixtes, Noroit Arras, Paris.
Livres d'artistes: Collection Sémaphore, Musée National d'Art Moderne, Centre Georges Pompidou, Paris.
Marseille: Premier Régard sur les collections, Musée Cantini, Marseille.
Transgressions, Galerie Gillespie-Laage-Salomon, Paris.
36 Artistes d'aujourd'hui pour Médecins sans Frontières, Chapelle de la Salpêtrière, Paris.

1986

Luxe, calme et volupté: Aspects of French Art 1966–1986, Vancouver Art Gallery, Expo 86.
Perspectives cavalières, Ecole Régionale Supérieure d'Expression Plastique, Tourcoing, France.
Photography as Performance: Message through Object & Pictures, The Photographers' Gallery, London.
Un Régard de Bruno Cora sur les oeuvres du Fonds Régional d'Art Contemporain Rhône-Alpes, Centre National d'Art Contemporain, Grenoble, France.
Turning over the Pages, Some Books in Contemporary Art, Kettle's Yard Gallery, Cambridge University, Cambridge, England.
Voyage en 1987 à Naples, Academia di Belle Arti, Naples.

1987

Des Animaux et des hommes, Musée d'Ethnographie, Neuchâtel, Switzerland.
Les Années 70. Les Années-Mémoire, Abbaye Saint-André, Centre National d'Art Contemporain, Meymac, France.
Exotische Welten, europäische Phantasien, Württembergischer Kunstverein, Stuttgart.
French Survey Show, Ivan Dougherty Gallery, Sydney.
Les Révélateurs, Galerie d'Art Contemporain du Centre Saint-Vincent, Herblay, France.
La Ruée vers l'art, Musée du Louvre, Paris.
Taxis avant minuit, Centre National des Arts Plastiques and Direction Régionale des Affaires Culturelles de l'Ile de France, Paris.

Wall Works, Cornerhouse, Manchester, England.

1988

Acquisitions 1988, Fonds National d'Art Contemporain, Centre National des Arts Plastiques, Paris.
L'Art moderne à Marseille, la collection du Musée Cantini, Centre de la Ville Charité and Musée Cantini, Marseille.
Auf zwei Hochzeiten Tanzen, Kunsthalle, Zurich.
Boltanski, Lavier, Messager, Galerie Wanda Reiff, Maastricht, The Netherlands.
Le Facteur Cheval et le Palais Idéal, Mairie de Hauterives, France.
Galerie Elisabeth Kauffmann, Basel.
Gran Pavese: The Flag Project, Museum van Hedendaagse Kunst, Antwerp, Belgium.
Der Hund in Mir, Galerie Hubert Winter, Vienna.
Jahresgaben 88, Kunstverein, Düsseldorf.
Maison de caractères, deuxième festival d'art contemporain, avant-propos, Château Coquelle, Rosendaël-Dunkerque, France.
Narrative Art, Fonds Régional d'Art Contemporain Bourgogne, Dijon, France.
Nature inconnue, Jardins de la Préfecture, Nevers, France.
Tradition contemporaine, Château Coquelle, Rosendaël-Dunkerque, France.

1989

Acquisitions récentes, Fonds National d'Art Contemporain, Centre National des Arts Plastiques, Paris.
Une Autre Affaire, Le Consortium, Centre d'Art Contemporain and Espace FRAC, Dijon, France.
Anamnèse, Dazibao, Centre de Photographies Actuelles, Montreal.
Les 100 Jours d'art contemporain de Montréal, Centre International d'Art Contemporain de Montréal.
Choix d'oeuvres du Fonds Régional d'Art Contemporain Aquitaine, Galerie d'Art Contemporain, Mourenx, France.
Festival de la Sorcellerie, Centre d'Art Contemporain, Castres, France.
Galerie Elisabeth Kauffmann, Basel.
Histoires de musée, Musée d'Art Moderne de la Ville de Paris.
Images of Women and Ideas of Nation, Hayward Gallery, London. (Traveled to Walker Art Gallery, Liverpool, England.)
L'Invention d'un art: Cent-cinquantième Anniversaire de la photographie, Musée National d'Art Moderne, Centre Georges Pompidou, Paris.
Peinture, cinéma, peinture, Centre de la Ville Charité, Marseille.
Shadow of a Dream, Cambridge Darkroom, Cambridge, England. (Traveled to Impressions, York; Untitled Gallery, Sheffield, England.)
Simplon Express, exhibition on train traveling from Paris to Zagreb.
Trajets, Galerie Crousel-Robelin BAMA, Paris.

1990

Les Choix des femmes, Le Consortium, Centre d'Art Contemporain, Espace FRAC, and L'Usine, Dijon, France.
La Collection des oeuvres photographiques, Musée de la Roche-sur-Yon, France.
Collections du Centre Pompidou, Deichtorhallen, Hamburg.
Collections du FRAC Corse, Fonds Régional d'Art Contemporain Corsica, France.
Contemporary Assemblage: The Dada and Surrealist Legacy, L. A. Louver, Venice, California.
The Eighth Biennale of Sydney: The Readymade Boomerang, Certain Relations in 20th Century Art, Art Gallery of New South Wales, Sydney.
Francja Dsisiaj, Muzeum Narodowe, Warsaw. (Traveled to Muzeum Narodowe, Krakow, Poland.)
Images in Transition: Photographic Representation in the Eighties, The National Museum of Modern Art, Kyoto. (Traveled to National Museum of Modern Art, Tokyo.)
Une Scène parisienne 1968–1972, Centre d'Histoire de l'Art Contemporain, Rennes, France. (Traveled to Fonds Régional d'Art Contemporain Bretagne, Châteaugiron, France.)
S. Charlesworth, J. Dunning, A. Messager, A. Piper, L. Simmons, Feigen, Inc., Chicago.
Stendhal Syndrome: The Cure, Andrea Rosen Gallery, New York.
Vies d'artistes, Musée des Beaux-Arts André Malraux, Le Havre, France. (Traveled to Usine Fromage, Rouen; Musée Ancien Evêché, Evreux, France.)

1991

Centro Cultural de Arte Contemporaneo, Mexico City.
La Collection, Château de Rochechouart, Musée Départemental d'Art Contemporain, Rochechouart, France.
Constructing Images: Synapse Between Photography and Sculpture, Lieberman & Saul Gallery, New York. (Traveled to Tampa Museum of Art, Tampa, Florida; Center for Creative Photography, University of Arizona, Tucson.)
O excesso & o recesso, 21ᵉ Biennale de São Paulo, Brazil.
Framed, Stephen Wirtz Gallery, San Francisco.
Individualités: 14 Contemporary Artists from France, Art Gallery of Ontario, Toronto.
L'Insoutenable Légèreté de l'art, Musée de la Roche-sur-Yon and Musée de Poitiers, France.
Koleksja, Muzeum Sztuki, Lodz, Poland, and Galerie Zacheta, Warsaw.
Plastic Fantastic Lover, Blum Helman Warehouse, New York.
The Second East-West Photo Conference, The Museum of Architecture, Wroclaw, Poland.
Sweet Dreams, Barbara Toll Fine Arts, New York.

1992

A Visage découvert, Fondation Cartier, Paris.
Animaux, Galerie Anne de Villepoix, Paris.
Annette Lemieux/Annette Messager, Josh Baer Gallery, New York.
Bild, Objekt, Skulptur, Galerie Elisabeth Kaufmann, Basel.
Corporal Politics, MIT List Visual Arts Center, Cambridge, Massachusetts.
Cragg, Dorner, Laib, Messager, Meyer, Schütte, Galerie Crousel-Robelin BAMA, Paris.
David Ireland, Annette Messager, Bill Viola, Gallery Paule Anglim, San Francisco.
Ephemeral, Galerie Wanda Reiff, Maastricht, The Netherlands.
Images, San Jose Museum of Art, California.
Lantz, Messager, Boltanski, McKeever, Galerie Elisabeth Kaufmann, Basel.
Oeuvres récentes, Galerie Crousel-Robelin BAMA, Paris.
Parallel Visions: Modern Artists and Outsider Art, Los Angeles County Museum of Art. (Traveled to Museo Nacional Reina Sofía, Madrid; Kunsthalle, Basel; Setagaya Art Museum, Tokyo.)
Photographies, Centre de la Ville Charité, Marseille.
Le Portrait dans l'art contemporain, Musée d'Art Moderne et d'Art Contemporain, Nice.
Une Sélection, Fonds Régional d'Art Contemporain Basse-Normandie, France.
The Self Revealed: The Collection of Kimberley Klosterman and Michael Lowe, The Cincinatti Contemporary Arts Center, Ohio.
Shapeshifters, Amy Lipton Gallery, New York.
Special Collections: The Photographic Order from Pop to Now, International Center of Photography Midtown, New York. (Traveled extensively in the United States and Canada.)
To Start a Collection, Galerie Wanda Reiff, Maastricht, The Netherlands.
Trans-Voices, American Center, Paris.
Transform, Galerie Elisabeth Kaufmann, Basel.
Zeichnungen für die Schülerinnen und Schüler von Le Landeron, Museum für Gegenwartskunst, Basel.

1993

American Art Today: Clothing as Metaphor, The Art Museum at Florida International University, Miami.
Anonymity & Identity and Oneiric Threshold, Anderson Gallery, Richmond, Virginia.
L'Autre à Montevideo—Homenaje à Isidore Ducasse, Museo Nacional de Artes Visuales, São Paolo, Brazil.
Biennale di Venezia, Venice.
De la main à la tête, l'objet théorique, Domaine de Kerguéhennec, Centre d'Art Contemporain, Bignan, France.
La Donation Vicky Rémy II: Les Grands illustrés, Musée d'Art Moderne, Saint-Etienne, France.

Eau de Cologne 83–93, Monika Sprüth Galerie, Cologne.
Empty Dress: Clothing as Surrogate in Recent Art, exhibition organized by Independent Curators Incorporated. (Traveled extensively in the United States and Canada.)
L'Envers des choses, Musée National d'Art Moderne, Centre Georges Pompidou, Paris.
Et tous ils changent le monde, 2ᵉ Biennale d'Art Contemporain de Lyon, France.
Fall from Fashion, The Aldrich Museum of Contemporary Art, Ridgefield, Connecticut.
Histoires de voir, Château de Villeneuve, Vence, France.
Hotel Carlton Palace, Chambre 763, Hotel Carlton Palace, Paris.
Image Makers, Nassau County Museum of Fine Art, Roslyn Harbor, New York.
Körper II, Galerie Elisabeth Kaufmann, Basel.
Living with Art: The Collection of Ellyn and Saul Dennison, The Morris Museum, Morristown, New Jersey.
Multiple Images: Photographs since 1965 from the Collection, The Museum of Modern Art, New York.
L'Ordre du temps, Domaine de Kerguéhennec, Centre d'Art Contemporain, Bignan, France.
Portraits: Oeuvres de la collection du FRAC Aquitaine, Galerie du TNB, Rennes, France.
Sonsbeek 93, Arnhem, The Netherlands.

1994

Arrested Childhood, Center of Contemporary Art, North Miami, Florida.
Les Chapelles de Vence, Vence, France. (Traveled to Chalon-sur-Saône; Centre d'Arts Plastiques Contemporains, Musée d'Art Contemporain, Bordeaux, France.)
Comme dans une image, Gilbert Brownstone & Cie., Paris.
Living in Knowledge—An Exhibition about the Questions Not Asked, Duke University Art Museum, Durham, North Carolina.
Melancholia, Fonds Régional d'Art Contemporain Auvergne, France.
On Nostalgia, The Gallery at Takashimaya, New York.
Photography and Beyond: New Expressions in France, Israel Museum, Jerusalem. (Traveled to Boca Raton Museum of Art, Boca Raton, Florida; Museum of Photographic Arts, San Diego.)
São Paolo Biennale, Brazil.
Le Saut dans le vide, Maison des Artistes, Moscow.
Trans, Galerie Chantal Crousel, Paris.

1995

New Works for a New Space, ArtPace, San Antonio, Texas.

Selected Bibliography

Books by Annette Messager and exhibition publications are listed chronologically; articles by her, including interviews, and writings about her are arranged alphabetically.

Books by Annette Messager

Les Approches. Brussels: Lebeer Hossman, 1973.

Mes Clichés par Annette Messager collectionneuse. Liège: Yellow Now, 1973.

Les Tortures volontaires. Copenhagen: Berg, 1974.

Ma Collection d'expressions et d'attitudes diverses par Annette Messager collectionneuse. Saarbrücken: Antiquarium; Antibes: Arrocaria, 1975.

Ma Collection de proverbes par Annette Messager collectionneuse. Milan: Giancarlo Politi, 1976.

Augures. Castres: Centre d'Art Contemporain, 1988.

Mes Enluminures. Dijon: L'Association pour la Diffusion de l'Art Contemporain, 1988.

Mes Ouvrages. Arles: Actes Sud, 1989.

D'Approche. Paris: Archives Librairie–Jean-Dominique Carré, 1995.

Nos Témoignages. Stuttgart: Oktagon Verlag, 1995.

Exhibition Publications
Solo Exhibitions

Annette Messager Sammlerin; Annette Messager Künstlerin. Munich: Städtische Galerie im Lenbachhaus, 1973. Texts by Messager, Günter Metken, and Armin Zweite.

Annette Messager collectionneuse. Paris: ARC, Musée d'Art Moderne de la Ville de Paris, 1974.

Mes Jeux de main par Annette Messager truqueuse. Zagreb: Galerija Suvremene Umjetnosti, 1975. Text by Annette Messager.

Galerie 't Venster, Rotterdam, 1975. Text by Gosse Oosterhof.

La Femme et . . . Annette Messager truqueuse. Geneva: Ecart, 1975.

Christian Boltanski/Annette Messager: Modellbilder, das Glück, die Schönheit und die Träume. Cologne: Rheinland; Bonn: Rudolf Habelt in Kommission, 1976. Texts by Klaus Honnef and Lothar Romain.

Annette Messager: "Les Vacances." Vaduz, Liechtenstein: Centre d'Art et de Communication, 1977.

Annette Messager Kolecje 1972–1975. Czervic: B.W.A.; Lublin: Salon Krytykow, 1978. Text by Carole Naggar.

Die Fortsetzungsromane mit Annette Messager Sammlerin, Annette Messager praktische Hausfrau, Annette Messager trickreiche Frau, Annette Messager Künstlerin. Edited by Klaus Honnef et al. Kunst und Altertum am Rhein, vol. 85. Cologne: Rheinland; Bonn: Rudolf Habelt in Kommission, 1978. Text by Klaus Honnef.

Serials. Warsaw: Galerie Foksal PSP, 1978. Text by Klaus Honnef.

Annette Messager. Zurich: Galerie Maeght, 1980.

Annette Messager: Statements New York 82. New York: Holly Solomon Gallery, 1982.

Statements 1. New York: Barbara Gladstone Gallery, 1982. Text by Otta Hahn.

Annette Messager/Chimères 1982–1983. Calais: Musée des Beaux-Arts, 1983. Texts by Bernard Marcadé, Annette Messager, and Dominique Viéville.

Annette Messager, chimères. Vienna: Galerie Grita Insam, 1984. Text by Bernard Marcadé.

Les Pièges à chimères. Paris: ARC, Musée d'Art Moderne de la Ville de Paris, 1984. Interview by Suzanne Pagé.

Annette Messager: Peindre, photographier. Nice: Musée de Nice, 1986. Texts by Démosthènes Davvetas and Claude Fournet.

Annette Messager, comédie tragédie, 1971–1989. Grenoble: Musée de Grenoble, 1989. Texts by Klaus Honnef, Serge Lemoine, Didier Semin, and others. Published in French/German (1989) and French/English (1991) editions.

Contes d'été. Rochechouart: Musée Départemental de Rochechouart, 1990. With Christian Boltanski. Text by Guy Tosatto.

Annette Messager: Faire des histoires/Making Up Stories. Toronto: Mercer Union and Cold City Gallery, 1991. Text by Annette Hurtig.

Annette Messager. Salzburg: Salzburger Kunstverein, 1992. Text by Kate Bush.

Annette Messager: Telling Tales. Bristol: Arnolfini; Manchester: Cornerhouse, 1992. Text by Mo Gourmelon.

in-scapes: Annette Messager. Iowa City: The University of Iowa Museum of Art, 1992. Text by Jo-Ann Conklin.

Faire parade. Paris: Musée d'Art Moderne de la Ville de Paris, 1995. Interview by Robert Storr and texts by Elizabeth Lebovici and Jean-Noël Vuarnet.

Group Exhibitions

Christian Boltanski, Jean LeGac, Annette Messager. Dijon: Musée Rude, 1973. Text by Marianne Lemoine.

Cinq Musées personnels. Grenoble: Musée de Peinture et de Sculpture, 1973. Text by Gilbert Lascault.

Identité-Identification. Bordeaux: Centre d'Arts Plastiques Contemporains, 1976. Artist interviews by Jacques Clayssen.

Trois Villes, trois collections. Saint-Étienne: Le Henaff, 1976. Texts by Marie-Claude Beaud, Bernard Ceysson, Pontus Hulten, and Marielle Latour.

Les Boîtes. Paris: ARC, Musée d'Art Moderne de la Ville de Paris, 1976. Texts by Suzanne Pagé, Françoise Chatel, and others.

Bookworks. New York: The Museum of Modern Art, 1977. Introduction by Barbara J. London.

Documenta 6. Edited by Joachim Diederichs et al. 3 vols. Kassel: Paul Dierichs, 1977. Text in vol. 2 by Klaus Honnef and Evelyn Weiss.

Eremit? Forscher? Sozialarbeiter? Edited by Herbert Hossman et al. Hamburg: Kunstverein, 1979.

European Dialogue: The Third Biennale of Sydney. Compiled by Kerry Crowley. Sydney: The Biennale, 1979. Texts by Nick Waterlow, Elwyn Lynn, Pontus Hulten, and others.

French Art 1979. London: Serpentine Gallery, 1979. Text by Judy Marle.

Tendances de l'art en France III, 1968–1978/79, partis-pris autres. Paris: Musée d'Art Moderne de la Ville de Paris, 1979. Text by Suzanne Pagé.

Trigon 79: Masculin Féminin. Graz, Austria: Graz—Trigon 79—Dreiländerbiennale, 1979.

Umrisse: Bilder, Objecte, Videos, Filmē von Künstlerinnen. Edited by Gesa Rautenberg. Kiel: Kunsthalle, 1979.

Dix Ans d'art en France. Musée d'Art Moderne de la Ville de Paris, 1980.

Ils se disent peintres, ils se disent photographes. Paris: Musée d'Art Moderne de la Ville de Paris, 1980. Text by Michel Nuridsany.

Settore arti visive. Venice: La Biennale di Venezia, 1980. Texts by Michael Compton, Martin Kunz, and others.

Autoportraits photographiques 1898–1981. Paris: Musée National d'Art Moderne, Centre Georges Pompidou; Éditions Herscher, 1981. Text by Denis Roche.

Façons de peindre. Chalon-sur-Saône, France: Maison de la Culture, 1981. Texts by Christian Besson and Michel Frizot.

Toyama Now 1981: For a New Art. Toyama: Museum of Modern Art, 1981. Texts by Michael Compton, Pontus Hulten, and others.

Typische Frau. Edited by Margarethe Jochimsen and Philomene Magers. Bonn: Bonner Kunstverein, 1981. Texts by Margarethe Jochimsen, Philomene Magers, and others.

De Matisse à nos jours: Tendances de l'art dans la région Nord-Pas-de-Calais depuis 1945. Lille: Musée des Beaux-Arts, 1982. Text by Gérard Durozoi.

Kunst mit Photographie. Berlin: Fröhlich und Kaufmann, 1983. Texts by Rolf H. Krauss, Manfred Schmalriede, and Michael Schwarz.

New Art at the Tate Gallery 1983. London: Tate Gallery, 1983. Text by Michael Compton.

Märchen, Mythen, Monster: Thema einer Sammlung. Cologne: Rheinland; Bonn: Rudolf Habelt in Kommission, 1984. Texts by Klaus Honnef, Peter Lüchau, and others.

Private Symbol, Social Metaphor: The Fifth Biennale of Sydney. Compiled by Paula Latos-Valier and Elizabeth Westwater. Sydney: The Biennale, 1984. Texts by Stuart Morgan, Nelly Richard, Annelie Pohlen, and others.

Ecritures dans la peinture. Nice: Villa Arson, 1984.

Ceci n'est pas une photographie. Mont-de-Marsan: Fonds Régional d'Art Contemporain Aquitaine, 1985. Text by Bernard Marcadé.

Dialog. Stockholm: Moderna Museet, 1985.

Livres d'artistes: Collection Sémaphore. Paris: Bibliothèque Publique d'Information, Centre Georges Pompidou, 1985. Text by Anne Moeglin-Delcroix.

Luxe, Calme et Volupté: Aspects of French Art 1966–1986. Vancouver: The Vancouver Art Gallery, 1986. Texts by Bernard Marcadé, Scott Watson, and others.

Photography as Performance. London: The Photographers' Gallery, 1986. Texts by David Briers, Susan Butler, Tony Arefin, and Maureen O. Paley.

Un Régard de Bruno Cora sur les oeuvres du Fonds Régional d'Art Contemporain Rhône-Alpes. Grenoble: Centre National d'Art Contemporain, 1986. Text by Bruno Cora.

Turning over the Pages, Some Books in Contemporary Art. Cambridge: Kettle's Yard Gallery, 1986. Text by Pavel Büchler.

Des Animaux et des hommes. Edited by Jacques Hainard and Roland Kaehr. Neuchâtel, Switzerland: Musée d'Ethnographie, 1987.

Exotische Welten, europäische Phantasien. Stuttgart: Cantz, 1987. Text by Tilman Osterwald.

Les Années 70. Les Années-Mémoire. Meymac: Abbaye Saint-André, Centre National d'Art Contemporain, 1987.

Perspectives cavalières. Tourcoing: Ecole Régionale Supérieure d'Expression Plastique, 1987. Text by Bernard Marcadé.

Auf zwei Hochzeiten Tanzen. Zurich: Kunsthalle, 1988. Text by Bernard Marcadé.

Gran Pavese: The Flag Project. Edited by Thérèse Legierse and Peter van Beveren. The Hague: SDU, 1988. Texts by Umberto Barbieri, Thérèse Legierse, and Peter Frank.

L'Art moderne à Marseille, la collection du Musée Cantini. Marseille: Musée Cantini, [1988]. Texts by Germain Viatte and others.

Acquisitions récentes. Paris: Fonds National d'Art Contemporain, 1989.

Histoires de musée. Paris: ARC, Musée d'Art Moderne de la Ville de Paris, 1989. Text by Suzanne Pagé.

L'Invention d'un art: Cent-cinquantième Anniversaire de la photographie. Paris: Adam Biro and Centre Georges Pompidou, 1989. Texts by Jean-Claude Lemagny, Alain Sayag, and others.

Peinture, cinéma, peinture. Marseille: Musées de Marseille; Paris: Hazan, 1989. Texts by Germain Viatte, Hubert Damisch, and others.

Shadow of a Dream. Cambridge: Cambridge Dark Room, 1989. Text by Véronique Pittolo.

Images in Transition: Photographic Representation in the Eighties. Kyoto: National Museum of Modern Art, 1990. Texts by Shinji Kohmoto and Alain Sayag.

Individualités: 14 Contemporary Artists from France. Toronto: Art Gallery of Ontario, 1990. Texts by Roald Nasgaard, Marie-Claude Jeune, and others.

The Readymade Boomerang, Certain Relations in 20th Century Art: The Eighth Biennale of Sydney. Sydney: The Biennale, 1990.

Les Choix des femmes. Dijon: Le Consortium, 1991.

L'Insoutenable Légèreté de l'art. La Roche-sur-Yon: Musée de La Roche-sur-Yon; Poitiers: Musée de Poitiers, 1991.

Une Scène parisienne 1968–1972. Rennes: Centre d'Histoire de l'Art Contemporain, 1991. Texts by Claire Legrand and others.

Corporal Politics. Cambridge, Mass.: MIT List Visual Arts Center; Boston: Beacon Press, 1992. Texts by Donald Hall, Thomas Laqueur, and Helaine Posner.

Parallel Visions: Modern Artists and Outsider Art. Los Angeles: Los Angeles County Museum of Art; Princeton: Princeton University Press, 1992. Texts by Carol S. Eliel, Maurice Tuchman, and others.

American Art Today: Clothing as Metaphor. Miami: The Art Museum at Florida International University, 1993. Text by Kay Larson.

Anonymity and Identity. Richmond: Anderson Gallery, Virginia Commonwealth University, 1993. Texts by Leslie A. Brothers, Dorit Cypis, and Steven S. High.

Empty Dress: Clothing as Surrogate in Recent Art. New York: Independent Curators Incorporated, 1993. Text by Nina Felshin.

Fall from Fashion. Ridgefield, Conn.: The Aldrich Museum of Contemporary Art, 1993. Text by Richard Martin.

Histoires de voir. Vence: Château de Villeneuve, 1993. Text by Xavier Girard.

Trésors de voyage. Venice: 45th Biennale di Venezia, Isola San Lazzaro, 1993.

Arrested Childhood. North Miami, Fla.: Center of Contemporary Art, 1994. Text by Bonnie Clearwater.

New Works for a New Space: Annette Messager, Felix Gonzalez-Torres, Jesse Amado. San Antonio, Texas: ArtPace, The Pace Roberts Foundation for Contemporary Art, 1995. Text by Robert Storr, interview by Frances Colpitt.

Articles by and Interviews with Annette Messager

"All the Parts of One's Life, All the Secrets, All the Hopes, Are in One's Clothes." *Aperture*, no. 130 (winter 1993): 48–53.

"Annette Messager entretien." Interview by Delphine Renard. *Flash Art France*, no. 9 (Fall 1985): 50–52.

"Annette Messager: Im Gespräch mit Bernard Marcadé." Interview. *Noema*, no. 32 (September/October 1990): 35–47.

"Art . . . art de plaire . . . artifice . . . art d'aimer et d'être aimée . . ." *Traverses*, no. 7 (February 1977): 152–55.

"La Double Vie d'Annette Messager racontée par Annette Messager." *Prospects* (June 1973): 4.

"Entretien avec Annette Messager." Interview by Bernard Marcadé. *Artefactum*, no. 2 (February/March 1984): 32–35.

"Interview avec Annette Messager." By Barbara Radice. *Flash Art*, no. 46–47 (June 1974): 40.

"Protection: A Project for *Artforum*." *Artforum* 27 (April 1989): 126–29.

"Talk Dirt: Interview with Annette Messager." By Gianni Romano. *Flash Art* 24, no. 159 (Summer 1991): 102.

"Vie du musée: Entretien avec Annette Messager." Interview by Catherine Lawless. *Les Cahiers du Musée National d'Art Moderne*, no. 27 (Spring 1989): 111–17.

Writings about Annette Messager

Acampo, Marly. "Women and Art." *Ruimte* (March 1993): 40–41.

Adams, Brooks. "The Museum as Studio." *Art in America* 77, no. 10 (October 1989): 63–65.

"Annette Messager." *Art en Garde*, no. 1 (June 1975).

Applebroog, Ida. "The '"I Am Heathcliffe" says Catherine' Syndrome." *Heresies—A Feminist Publication on Art and Politics*, no. 2 (May 1977): 118–24.

Bataillon, Françoise. "Annette Messager. Arles." *Beaux-Arts Magazine*, no. 70 (July/August 1989): 111.

Besacier, Hubert. "Sweet Sadism: Annette Messager's Collection." *Artscribe*, no. 82 (Summer 1990): 60–61.

Biard, Ida. "Annette Messager." *Flash Art*, no. 113 (Summer 1983): 71.

Bouisset, Maïten. "Annette Messager l'ensorceleuse." *Beaux-Arts Magazine*, no. 59 (July/August 1988): 95.

Cameron, Dan. "Sculpting the Town—Sonsbeek 93." *Artforum* 32, no. 3 (November 1993): 89–90.

Chalumeau, Jean-Luc, and Catherine Flohic. "Annette Messager." *Eighty: Les Peintures en France dans les années 80*, no. 32 (March/April 1990): 2–32.

Cornand, Brigitte. "Vous prenez quel appart." *Actuel*, no. 47.

———. "Annette Messager." *Actuel*, no. 71.

Cornand, Brigitte, and Jean-François Bizot. "Le Mauvais Esprit européen est inqualifiable." *Actuel*, no. 86.

"Dans l'intimité d'Annette Messager collectionneuse." *Chroniques de l'art vivant*, no. 46 (February 1974): 26–27.

Darriulat, Jacques. "Annette Messager collectionneuse." *Combat* (27 May 1974).

Dayde, Emmanuel. "Annette Messager." *Museart* (February 1990): 123.

Dupuis, Sylvie. "Annette Messager." *Art Press*, no. 24 (January 1979): 24.

Fleury, Jean-Christian. "Vies d'artistes: Des Vies très exposées." *Photographies Magazine*, no. 29 (January/February 1991).

Foray, Jean-Michel. "Annette Messager: Collectionneuse d'histoires." *Art Press*, no. 147 (May 1990): 14–19.

Gourmelon, Mo. "Arbitrated Dissections: The Art of Annette Messager." *Arts Magazine* 65, no. 3 (November 1990): 66–71.

Grenier, Catherine. "Annette Messager." *Art Press*, no. 97 (November 1985): 74.

——— "L'Envers des choses." *Le Magazine*, no. 77 (September/November 1993): 8.

Grout, Catherine. "La sombra del parajo disecado." *El Guia* 1, no. 12 (February 1990): 51.

Gumpert, Lynn. "Annette Messager, Comédie Tragédie." *Galeries*, no. 35 (February/March 1990): 86–89, 138.

Honnef, Klaus. "Les Images du bonheur: Christian Boltanski, Annette Messager." *Art Press International*, no. 2 (November 1976): 20–21.

Jonquet, François. "Les Cérémonies secrètes d'Annette Messager." *Globe Hebdo* (11–17 August 1993): 58–59.

Kontova, Helena, and Giancarlo Politi, eds. "Post Conceptual Romanticism." *Flash Art*, no. 78/79 (November–December 1977): 23–36.

Lamarche-Vadel, Gaëtane. "Tout sur Annette Messager." *Opus International*, no. 52 (September 1974): 54–57.

Lascault, Gilbert. "Les Travaux de la femme." *Chroniques de l'art vivant*, no. 38 (April 1973): 14–16.

———. "Les Musées personnels comme productions artistiques." In *Actualité des arts plastiques*. Paris: Centre National de Documentation Pedagogique, 1978.

———. "L'Oeil dans l'araignée." *La Quinzaine littéraire*, no. 392 (April 1983): 22.

Le Foll, Joséphine. "Annette Messager/Christian Boltanski." *Galeries*, no. 38 (August/September 1990): 133.

Marcadé, Bernard. "Les Accouplements monstrueux d'Annette Messager." *Art Press*, no. 69 (April 1983): 18–19.

———. "This Never-Ending Ending . . ." *Flash Art*, no. 124 (October/November 1985): 36–39.

———. "Annette Messager." *Bomb*, no. 26 (Winter 1988/1989): 28–33.

Nadaud, Catherine. "La Robe de Jeanne d'Arc." *Les Nouvelles littéraires* (7 September 1983).

Neusüss, Floris, ed. *Fotografie als Kunst, Kunst als Fotografie*. Cologne: DuMont, 1979. Texts by Klaus Honnef, Margarethe Jochimsen, Floris Neusüss, and others.

Noise, no. 12 (1990): 4–9.

Nuridsany, Michel. "Annette Messager, belle de jour." *Art Press*, no. 125 (May 1988): 26–27.

Parsons, Louise. "Annette Messager: Telling Tales." *Contemporary Art* 1, no. 2 (Winter 1992/1993): 5–7.

Perchuk, Andrew. "Annette Messager." *Artforum* 32, no. 4 (December 1993): 82.

Pohlen, Annelie. "Rollen und Clichés." *General Anzeiger*, no. 27 (27 April 1978).

——— "The Utopian Adventures of Annette Messager." *Artforum* 19, no. 1 (September 1990): 111–16.

Proudhon, Françoise-Claire. "Annette Messager." *Flash Art*, no. 142 (October 1988): 142.

"4 Identités d'Annette Messager." *Flash Art*, no. 68–69 (October/November 1976): 32–33.

Rex, Jytte. "Orden noget stadigt truendes." *Kvinder* (February 1975).

Robinson, Hillary. "Annette Messager—Telling Tales." *Circa Art Magazine*, no. 63: 54–55.

Rochette, Anne, and Wade Saunders. "Savage Mercies." *Art in America* 82, no. 3 (March 1994): 78–83.

Rouzand, Jean. "Annette Messager." *Actuel*, no. 30.

"La Ruée vers l'art." In *Arts Info*. Paris: Ministère de la Culture et de la Communication, 1987.

Saglio, Jérôme. "Christian Boltanski—Annette Messager." *Galeries*, no. 32 (August/September 1989): 121.

Schmetterling, Astrid. "Annette Messager." *Art Monthly*, no. 159 (September 1992): 21.

Schütz, Sabine. "Märchen, Mythen, Monster." *Die Kunst*, no. 7 (July 1985): 538–44.

Sloan, Johanne. "Fake Animals, Anthropomorphism and Other Travesties of Nature." *Parachute*, no. 72 (October–December 1993): 18–21.

Soutif, Daniel. "Annette Messager." *Artforum* 27, no. 2 (October 1988): 160–61.

Thomas, Mona. "Annette Messager." *Beaux-Arts Magazine*, no. 10 (February 1984): 85.

———. "Annette Messager." *Beaux-Arts Magazine*, no. 27 (September 1985): 80–81, 106.

———. "Nice: Peindre et photographier." *Beaux-Arts Magazine*, no. 34 (April 1986): 92.

———. "Annette Messager à Dijon. Décors de corps en clichés drôles." *Politis*, no. 19 (26 May 1988).

———. "Les ficelles d'Annette." *Beaux-Arts Magazine*, no. 74 (December 1989): 58–63.

———. "Annette Messager." *Pirana*, no. 7.

Touratier, Jean-Marie. "Trois Femmes et les stéreotypes: Christine Bourel, Danielle Colomine, Annette Messager." *Opus International*, no. 69 (Fall 1978): 26–28.

Traverses, no. 4 (Winter 1992): 140–41.

Troncy, Eric. "Annette Messager: From Statements on a Life of Mediocrity to the Wondrous Postulates of Fictions." *Flash Art* 24, no. 159 (Summer 1991): 103–5.

Whiles-Serreau, Virginia. "Annette Messager." *Artscribe*, no. 55 (December/January 1986): 86.

Zanger, Marion de. "A. Messager: My Work Speaks Simply of the Body." *Ruimte* 6, no. 1 (January 1989): 11–18.

Lenders to the Exhibition

Clyde and Karen Beswick, Los Angeles
Ruth and Jacob Bloom
Chantal Crousel
Galerie Chantal Crousel, Paris
Galerie Laage-Salomon, Paris
Steven Johnson and Walter Sudol
Annette Messager
Musée d'Art Moderne de la Ville de Paris
Musée Cantini, Marseille
Musée de Grenoble
Musée National d'Art Moderne,
 Centre Georges Pompidou, Paris
The Museum of Modern Art, New York
The Neuberger and Berman Collection
Gabrielle Salomon
The Sandor Family Collection
Nancy and Elise de la Selle
Michael Harris Spector and Dr. Joan Spector
Weil, Gotshal & Manges
Tracy Williams